AROUND THE WORLD IN CUT-OUTS

PAPERBOYO

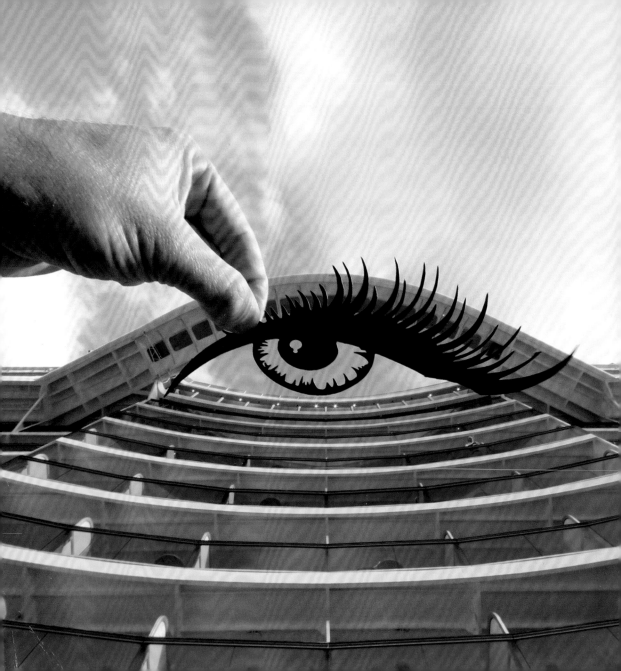

For anyone struggling to see more
than just what's in front of them

CENTURY

20 Vauxhall Bridge Road
London SW1V 2SA

Century is part of the Penguin Random House group of companies whose
addresses can be found at global.penguinrandomhouse.com.

Penguin
Random House
UK

First published in 2017 by Century

www.penguin.co.uk

A CIP catalogue record for this book is available
from the British Library.

ISBN 978 1 7808 9700 4
Around the World in Cut-Outs

Photographs by Rich McCor 2017
except p188 (main image) @levanterman; p188 (passport and ticket) © Shutterstock;
pp189–191 and p195 Chinese Tourist Board;
p192 @marcusmaschwitz; p194 (main image) @rekfrog1;
p195 (scalpel) Evan-Amos (own work), via Wikimedia Commons

Designed by
Tim Barnes ℝ chicken, herechickychicky.com

Every reasonable effort has been made to contact all copyright holders,
but if there are any errors or omissions, we will insert the appropriate acknowledgement
in subsequent printings of this book.

Colour origination by Born Group
Printed and bound in China by C&C Offset Printing Co. Ltd

Penguin Random House is committed to a sustainable future
for our business, our readers and our planet. This book is made from
Forest Stewardship Council® certified paper.

CONTENTS

INTRO

I'm not the first person to start a book with this quote, and I won't be the last:

'When a man is tired of London, he is tired of life.'

I was sitting on the 137 bus on the way home from work a few years ago, watching the familiar London scenery blur past me, when the bus stopped and on the street I noticed a group of tourists laughing with each other as they took photos. My elbow was resting against the window with my palm squashing my face, and I suddenly felt quite boring. I was living in a city that attracted millions of people from around the world, and yet here I was, keen to get home to reheat some pasta. I guess it's pretty natural when you become familiar with your surroundings that you lose a sense of wanderlust, but I didn't want to let go of it. I wanted to feel that inquisitiveness and sense of adventure that I had when I was backpacking, so I made a conscious effort to find wanderlust in London by exploring the city and doing the things that tourists did. I needed a travel companion, though, so I picked up my camera and took it with me.

Fast forward a couple of months and I'd seen Trafalgar Square fill with a golden sunrise, I'd snapped the distant horizons of London from the top of Monument, and I'd nestled amongst excited tourists as the sun fell behind Westminster. Along the way I'd seen things I'd ignored before, I'd met fascinating people, and I'd constantly been surprised by history that I'd previously been so oblivious to. And now, every time I had my camera with me, I had that excitement you feel when you're on an adventure. I spent almost every evening and weekend over those two months becoming a tourist in my own city and I loved it.

By this point photography was still just an excuse to go and explore, but I was paying more attention to the craft because when I joined Instagram, I noticed that my photos looked similar to everyone else's. I tried to emulate professional photographers, but nothing I shot was anything close to the dizzyingly high standards of their images. Then, standing on Westminster Bridge one day, I had the idea to combine my new love of photography with an old love: paper-cutting. I'd been into paper-cutting since I'd made music videos for a friend's band (instead of hiring actors I made paper characters because we had no money), so I went back to the bridge a few days later with a paper cut-out I'd made and took a photo of Big Ben with it. I looked down at my viewfinder and I liked it; a passing father and his daughter, intrigued by what I was doing, liked it too; and it went down well when I shared it on Instagram. I came up with a few more ideas combining photography with paper-cuts, and decided that instead of striving to take perfect photos, this would be my thing.

It wasn't immediately obvious but it was my failure to become one kind of photographer that ultimately helped me find the thing that set me apart, and after I'd taken a number of these photos in London, people took notice of my unique style and shared my images. I saw numerous headlines about my work with clichés such as 'a new perspective on the world' and 'seeing things differently', but they were entirely apt, even more so than they intended to be. That mini epiphany I had had on the 137, with my palm-squashed face and Samuel Johnson's words in my head, gave me a new perspective on the world, and it inspired me to put a new perspective on the world in return.

So as you travel through these images, I hope they'll inspire a hint of wanderlust in you and make you look at the world around you a little closer, because you never know where curiosity might take you. I thought I was just messing around with my camera in London that day, but it led to an adventure around the world.

Rich McCor, 2017

LANDMARKS

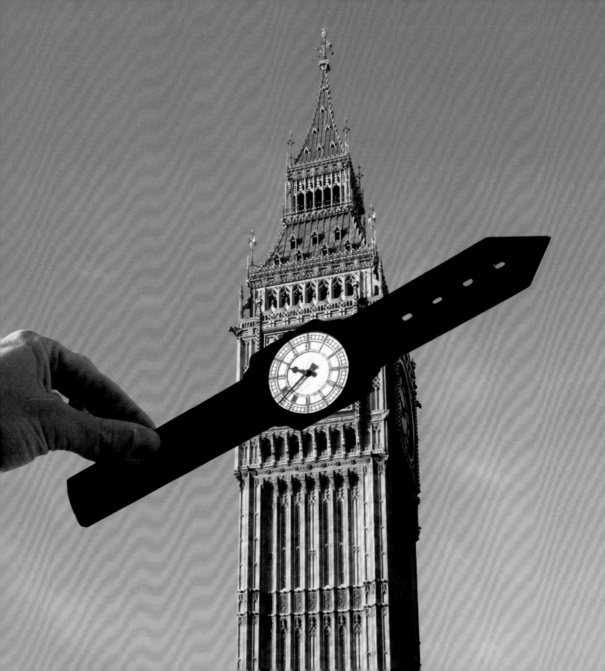

London, UK

BIG BEN

This is the first concept I had for combining a landmark with a paper cut-out. I remember a father and daughter walked past me as I was taking the photo on Westminster Bridge and asked what I was doing. When I showed them the photo, the guy said, 'Have you done this with other buildings?' I said, 'No'. 'You should,' he said.

Pisa, Italy

✂

LEANING TOWER OF PISA

In 1944, the 'Tiltin' Hilton' (as the US soldiers referred to it) was
suspected of being used by the Nazis as a lookout tower, so Staff
Sgt Leon Weckstein was tasked with scouting the tower to confirm
suspicions. From a nearby olive grove, he peered through his
binoculars looking for signs of life; his orders were that if he saw
movement he would call 'Fire!' down the radio and the tower would
be demolished in seconds. But just as he studied the landmark,
bombs exploded nearby and Weckstein was ordered to retreat.
Had he seen anyone in the tower, the famous landmark may not
still be standing today. In an interview with the *Guardian* in 2000 he
was asked if he thought the Germans were in the tower: 'You know
something? I've had fifty years to think about it, and I'm pretty sure
they were.'

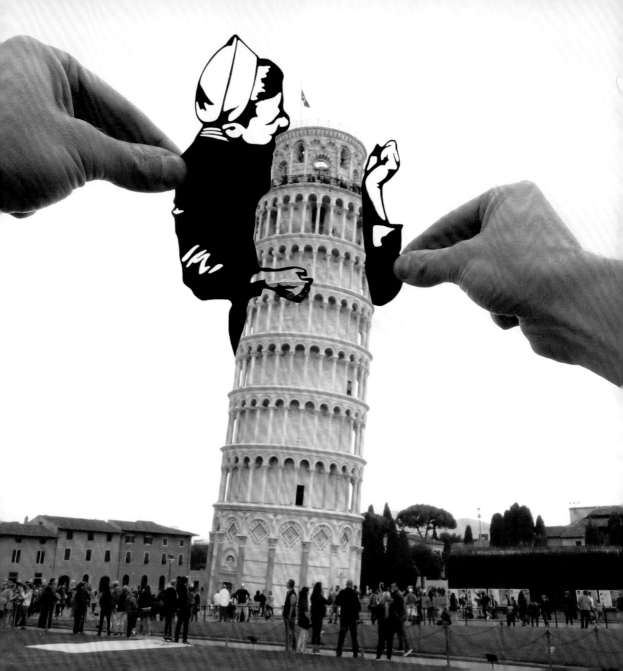

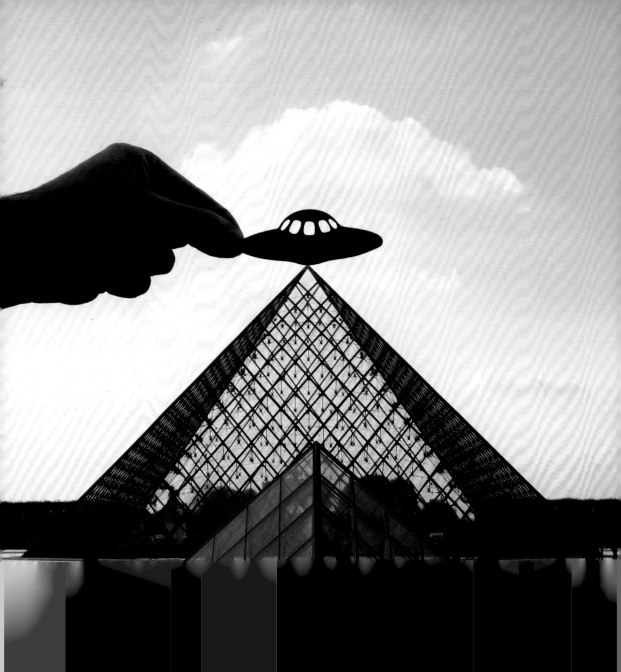

Paris, France

LOUVRE PYRAMID

When the *Mona Lisa* was stolen from the Louvre in 1911, the museum shut down for nine days, the French border was closed and all departing ships and trains were searched. The mystery wasn't solved until two years later when the thief turned out to be Vincenzo Peruggia, a carpenter who had been working at the museum. Peruggia knew all the escape routes and had even helped build the glass case that the *Mona Lisa* was displayed in, so he knew how to get to the painting. One night, he hid in a broom closet until after closing time, broke into the case and then walked out quietly onto the streets of Paris with the *Mona Lisa* under his coat...

Dubai, United Arab Emirates

BURJ KHALIFA

When the Burj Khalifa was built, one of the many things the construction team had to get right was the concrete mixture – if it set too quickly in the heat of Dubai then it would be likely to crack and weaken. To combat this, the team didn't pour the concrete in the daytime during the summer months – instead it was laid at night when the air was cooler. But even then the mixture was still too warm, so they added ice to the concrete – lots of ice. So in a way you could say the Burj Khalifa is a sort of igloo... kinda.

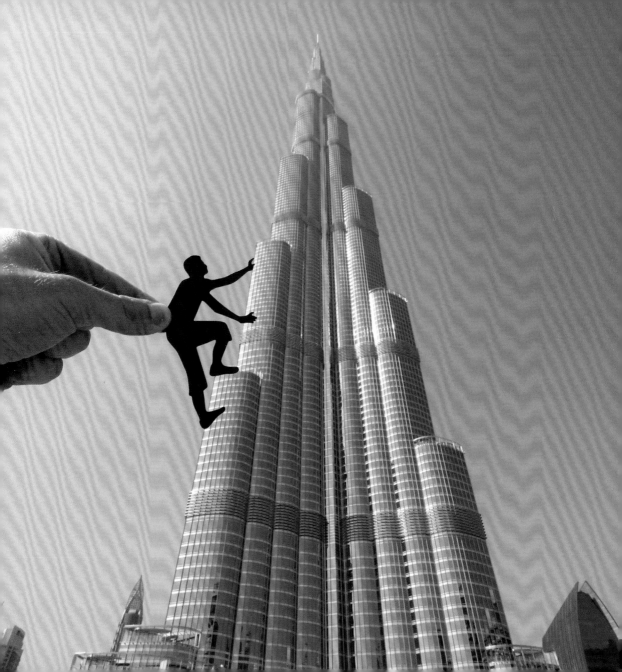

Florence, Italy

'DAVID'
by Michelangelo

In 1857, the Grand Duke of Tuscany surprised Queen Victoria with a replica of Michelangelo's *David*. Queen Victoria was so embarrassed by David's nudity that she requested a fig leaf be created to preserve his modesty whilst it went on display in London. I did make a leaf cut-out which would have suited this caption better, but David in underwear made me (and a few of the other tourists in the museum) laugh more.

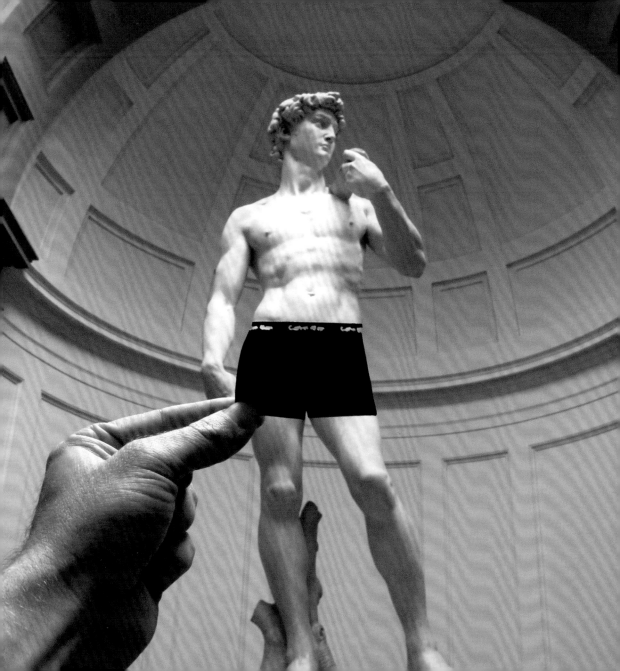

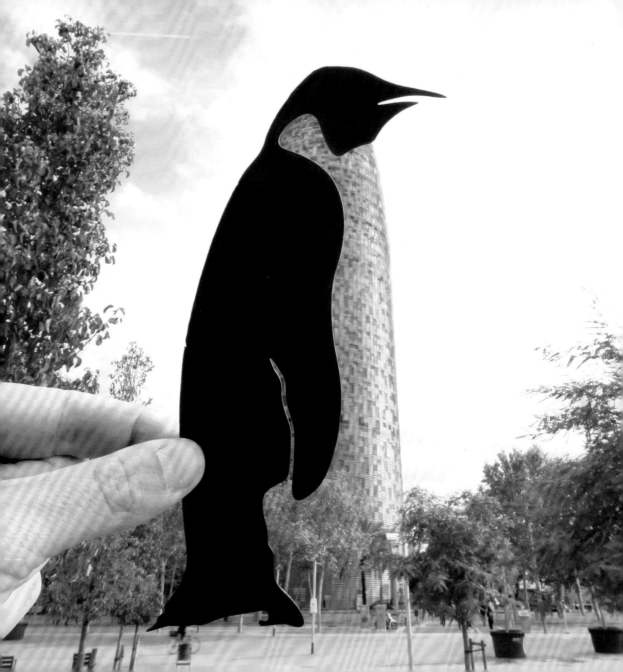

Barcelona, Spain

TORRE AGBAR

I had tried this idea on 30 St Mary Axe (AKA The Gherkin) in London, but just couldn't find the right vantage point to make the illusion work well enough. So when I was in Barcelona, I was pretty excited about finding this building, which suited the concept perfectly.

Los Angeles, California

SANTA MONICA FERRIS WHEEL

The previous ferris wheel that stood here was recently sold, believe it or not, on eBay... It was replaced by this bigger, solar-powered wheel. The winning bid for the old one was $132,400. I have no idea how much the postage and packaging was for it.

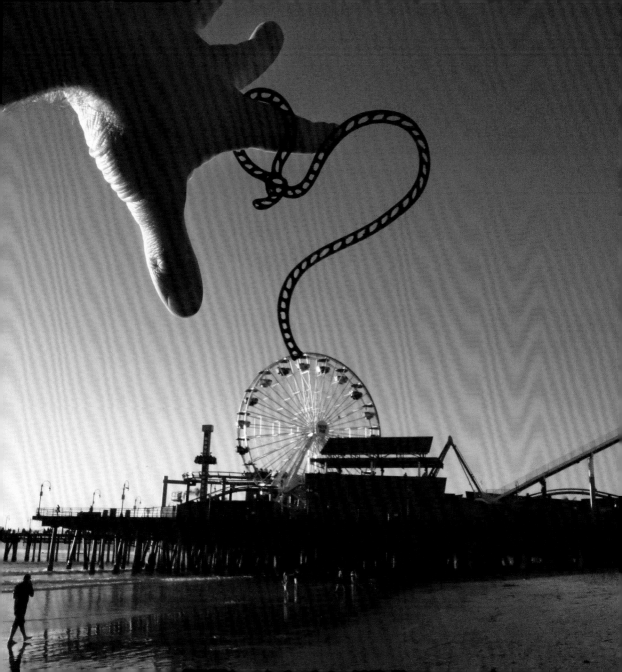

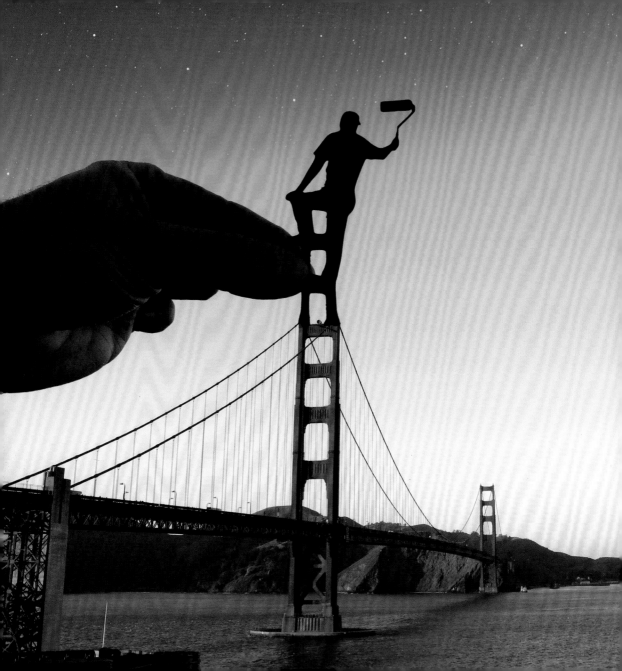

GOLDEN GATE BRIDGE

San Francisco, California, USA

When the Golden Gate Bridge was finished in 1937, the city celebrated for a week. The first day the bridge opened, there were plenty of eager people who wanted to be the first to do something unusual on the bridge, so pretty quickly records were set for people unicycling, walking on stilts, and playing the harmonica, amongst other bizarre feats. I think the most impressive stat belongs to the hot-dog vendors who sold somewhere around 50,000 hot-dogs and after that day never had to work again... probably.

Paris, France

EIFFEL TOWER

There is a man in Paris who invites strangers to his house for a dinner party every Sunday. He's been doing this for over thirty years and by all accounts it's a brilliant experience. If you're heading to Paris, you can register on his website to be invited: jim-haynes.com.

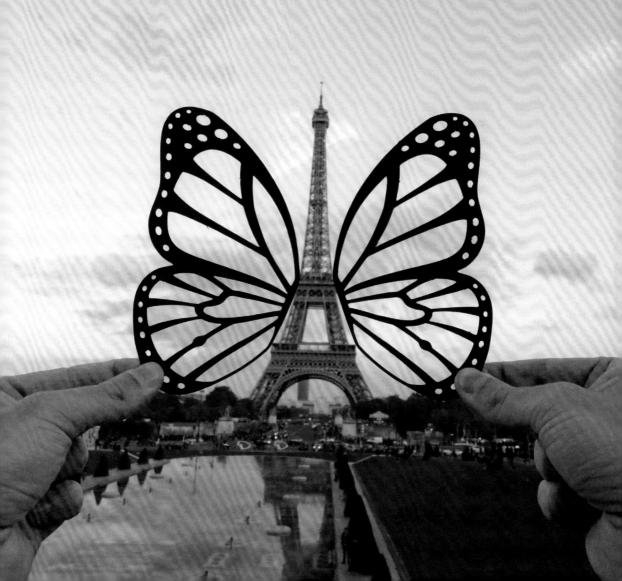

San Francisco, California, USA

COIT TOWER

One of the best views in San Francisco is from the observation deck of Coit Tower on Telegraph Hill. If you ever visit, I recommend venturing up there via the stairs on Filbert Street – you'll pass along gardens and quaint cottages; and every time you turn around to check your progress, more and more of the city reveals itself below.

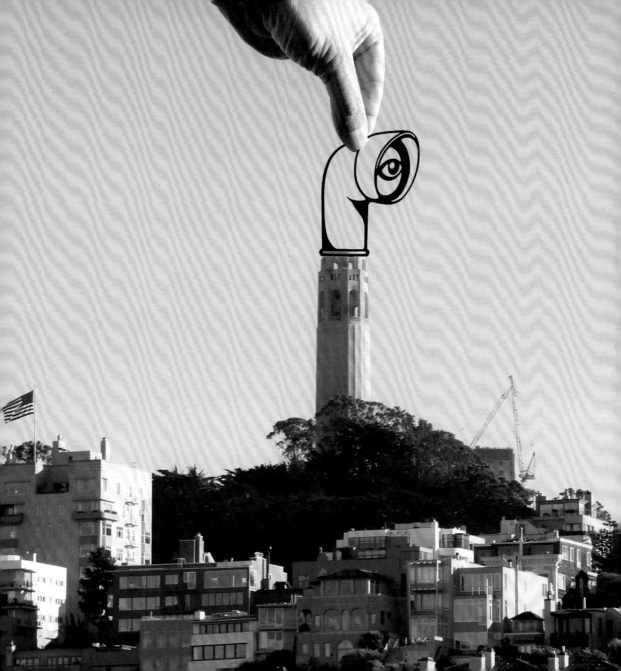

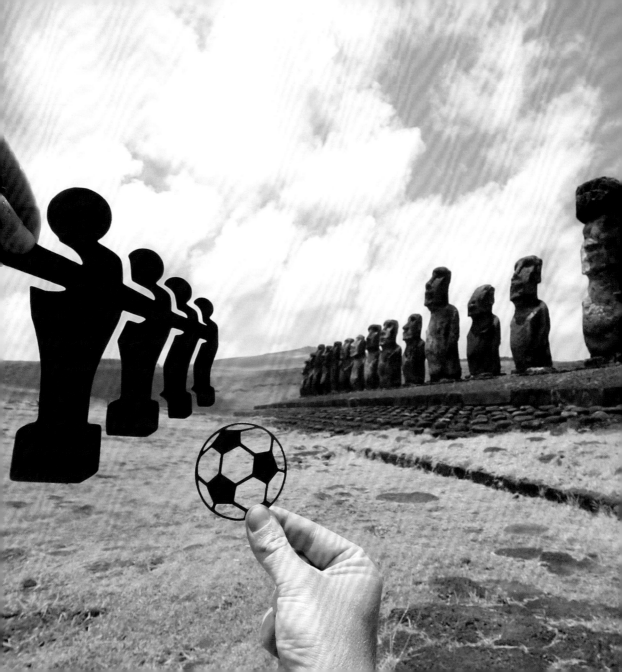

Easter Island (Chile), South Pacific

AHU TONGARIKI

At some point in the hazy history of Easter Island, the stone heads (*moai*) across the entire island were violently brought down. Theories collide as to what happened: some blame an island civil war, some point to reports of the 'earth shaking', and others suspect a tsunami devastated the coastline where they stood. Today around fifty statues have been resurrected, including this line-up of fifteen at Ahu Tongariki.

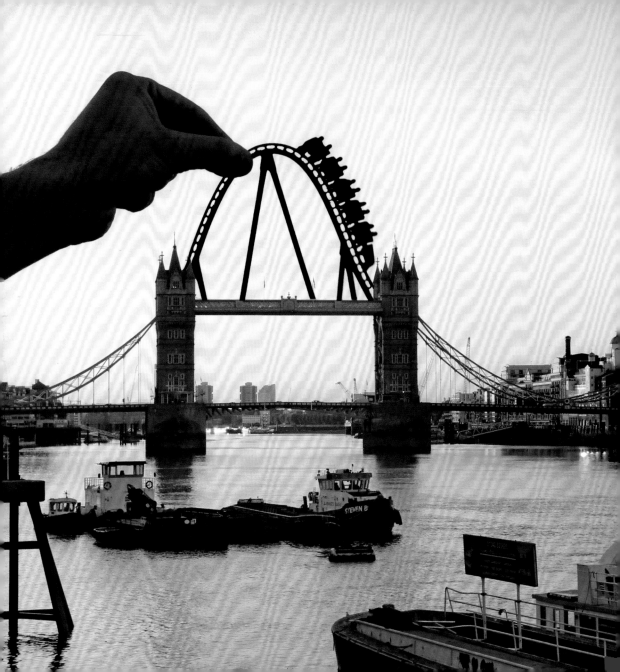

London, UK

TOWER BRIDGE

For quite a while I couldn't come up with any ideas that I liked for Tower Bridge, and then one day I was chatting to friends about commuting in London. At some point one of them said, 'I wish there was a rollercoaster in central London'...

Seoul, South Korea

LOTTE WORLD TOWER

Opened in April 2017, this is the world's fifth- tallest building.
Before it was completed, though, Ukrainian daredevil photographer
Vitaliy Raskalov managed to get past guard dogs, surveillance
drones and security personnel to capture a shot from the top of
the building. A spokesman for the Tower commented afterwards
that because, 'Raskalov climbs buildings in the most nonsensical
methods by climbing up walls or exterior surfaces, it is difficult to
prevent his entry into the building.' So difficult that the Chinese
authorities have reportedly banned Raskalov and his photography
partner Vadim Makhorov from ever entering China again, after their
exploits during the Lunar New Year in 2014 when they climbed the
Shanghai Tower, the world's second-tallest building!

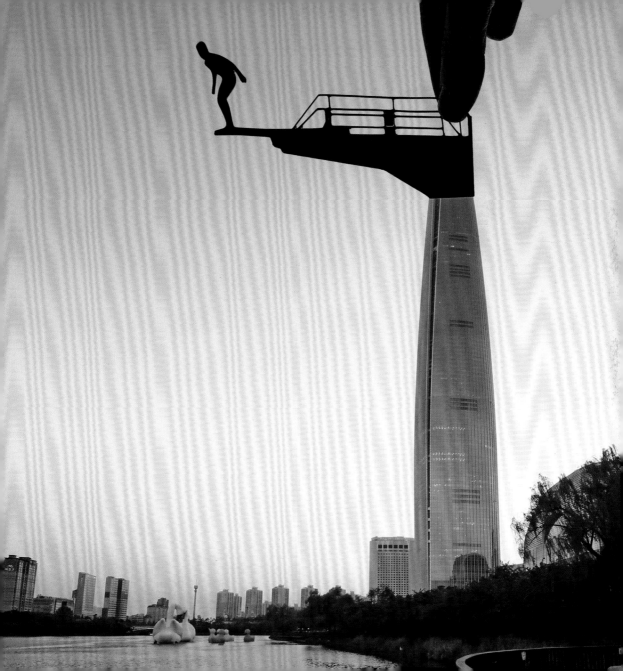

Rome, Italy

THE COLOSSEUM

Naumachia is the word Romans used to describe simulated naval fights – they were like gladiator battles on a bigger and wetter scale. Sometimes special structures were built and other times lakes were used, but there is evidence that the Colosseum was once turned into a gladiatorial water world. According to the Roman historian Cassius Dio, a sea fight took place in the amphitheatre in AD 86. Every effort was made to make a *naumachia* a colossal event, with ships, weapons, thousands of men and even sea creatures shipped in from around the globe.

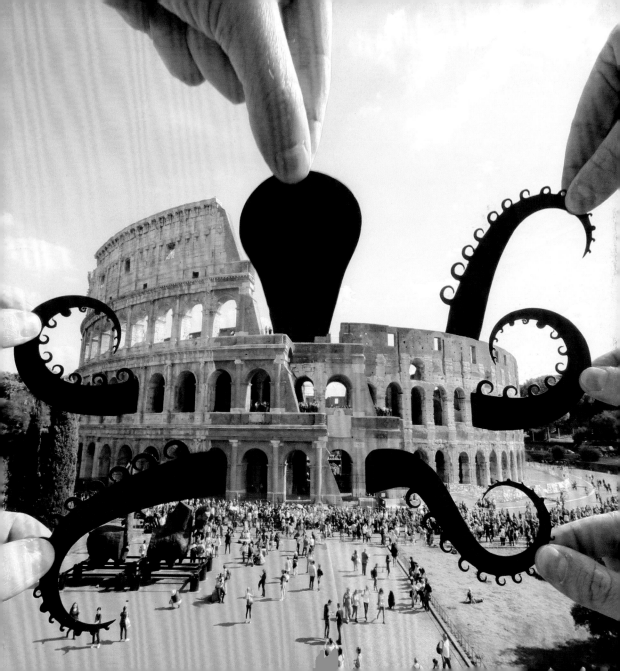

Reykjavik, Iceland

HALLGRÍMSKIRKJA

Hallgrímskirkja Church recently featured on a list of the world's strangest buildings; the Danish publication *Politiken* has named it one of the world's 'most unbelievable' buildings; and if that wasn't enough to confirm its status, in 2014 it was voted one of the strangest buildings in the world on the website Strange Buildings. I guess the point here is that some people think this building looks rather strange. Something that's also strange, though, is that the large clock on the tower, the most visible timepiece in town, often gives the wrong time. The reason? Large gusts of Icelandic wind frequently knock the hands out of step.

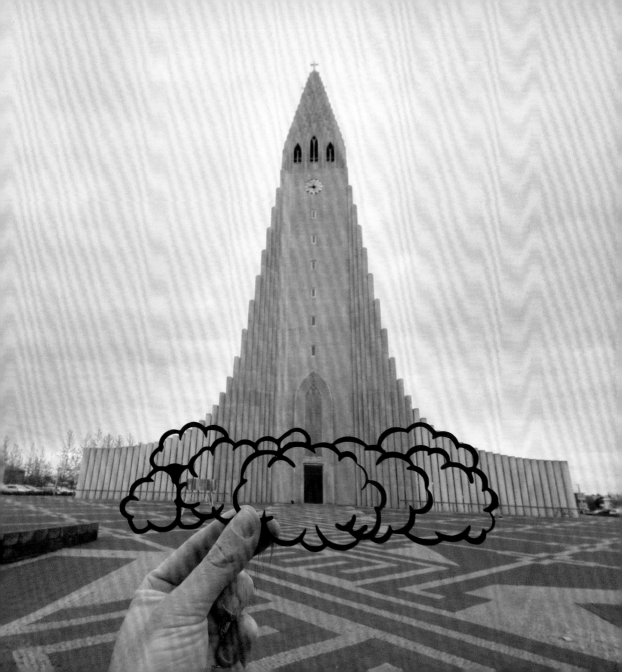

Edinburgh, Scotland

NATIONAL MONUMENT OF SCOTLAND

Not far from this spot on Calton Hill, in the Canongate Kirkyard, there was, until the 1930s, a tombstone for Ebenezer Scroggie. On a visit to Edinburgh, Charles Dickens read the inscription on the tomb as 'mean man', which inspired one of his most infamous literary creations. Dickens made a mistake, though: the inscription actually read 'meal man' in recognition of Scroggie's career as a corn trader.

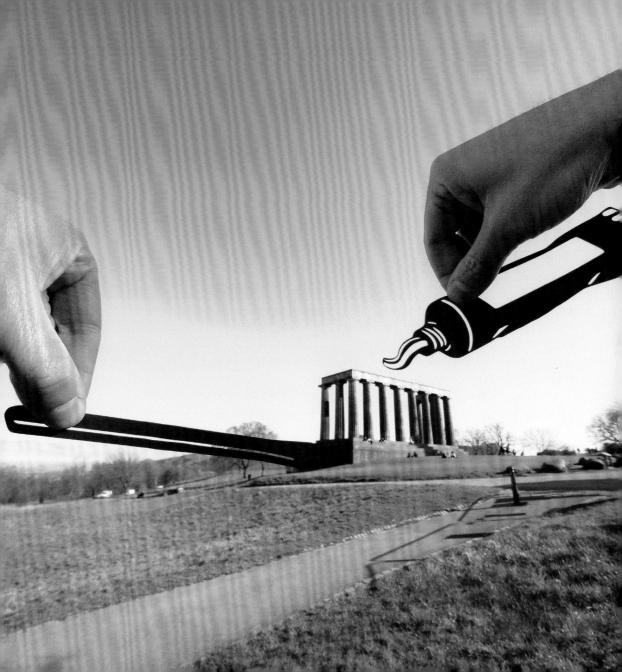

Paris, France

'THE THINKER'

by Auguste Rodin

I often get asked by curious tourists what I'm up to when I'm holding up bits of
paper in one hand and my camera in the other. My explanation tends to get
mixed reactions; some people don't understand why I bother and some love the
idea of embellishing iconic scenes with a sense of humour. I kind of like that I can
never predict what sort of reaction I'll get from different people.

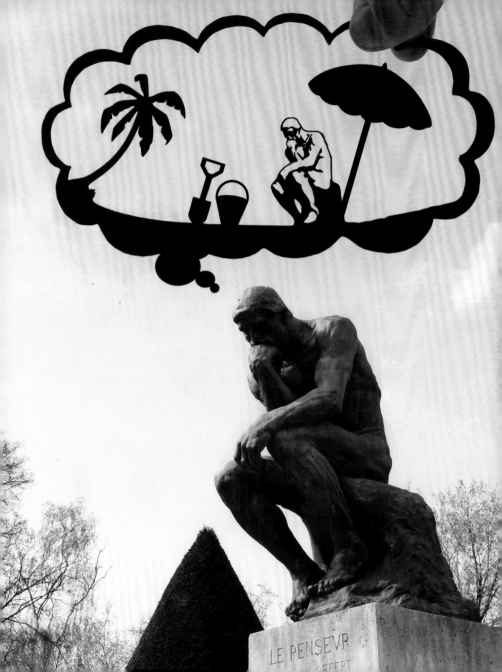

LE PENSEUR

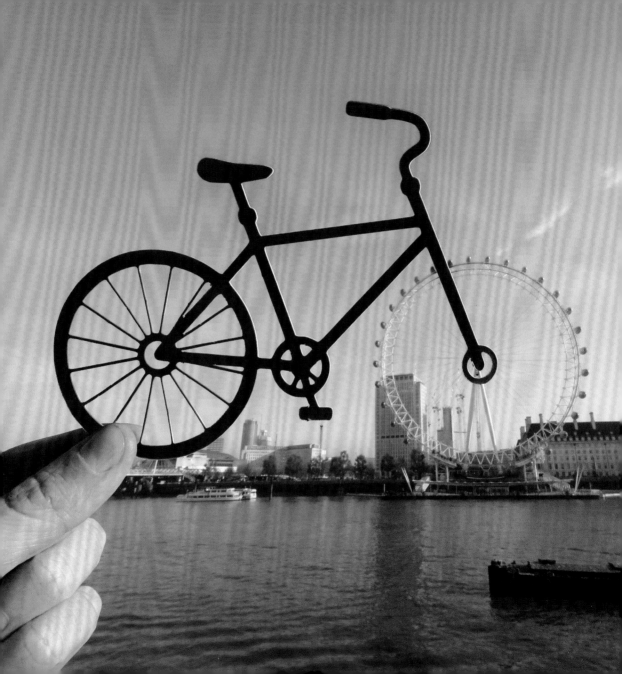

London, UK

THE LONDON EYE

In 1993 a competition was launched to design a landmark to commemorate the millennium in London. Julia Barfield and her husband entered the design for a large wheel on the Southbank. They didn't win. Nobody did – the judges didn't think any of the ideas were good enough. But Julia and David went to the council, then County Hall, then the Southbank Centre, then the Port Authority and then all thirty-two boroughs in London. Seven years later the London Eye was built. That's a lesson in perseverance.

Victoria Peak, Hong Kong

✂

PEAK TOWER

From the Peak Tower can you see the iconic Bank of China building down below – you can't miss its quirky and bold design. In terms of Feng Shui, though, the bank's skyscraper is considered 'aggressive' because the edges of the triangles point towards its rivals – a 'direct attack' in Feng Shui. So nearby HSBC responded to this 'attack'. They installed two maintenance cranes on their roof but had them specifically designed to look like cannons and pointed them directly at the Bank of China.

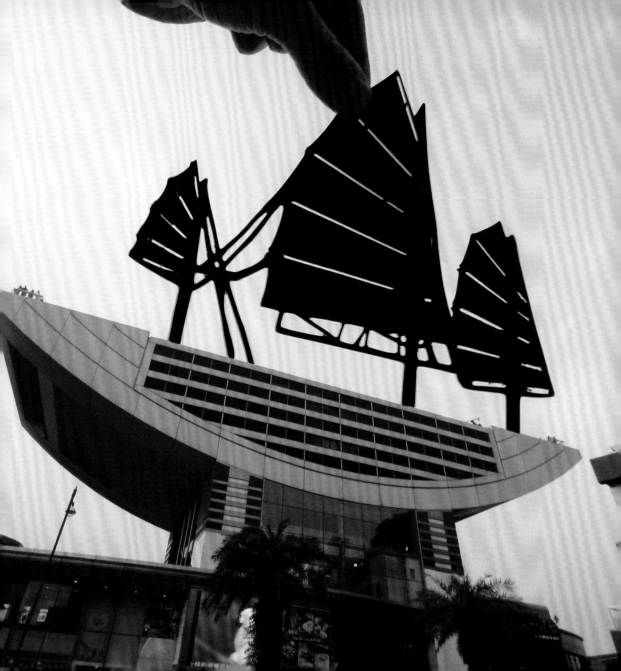

Singapore

MARINA BAY SANDS HOTEL

The Marina Bay Sands is one of the most iconic buildings in
Singapore, but not the tallest. In fact, central Singapore has a
skyscraper limit of 280m due to the proximity of the airport. Over the
last few decades three buildings in Singapore were built right up to
the imposed limit, but in a bid to outdo its rivals, One Raffles Place
opened a rooftop bar on its building. Therefore a 2m glass parapet
had to be added as a safety measure for guests. So technically
(and sneakily) One Raffles Place is Singapore's tallest building.

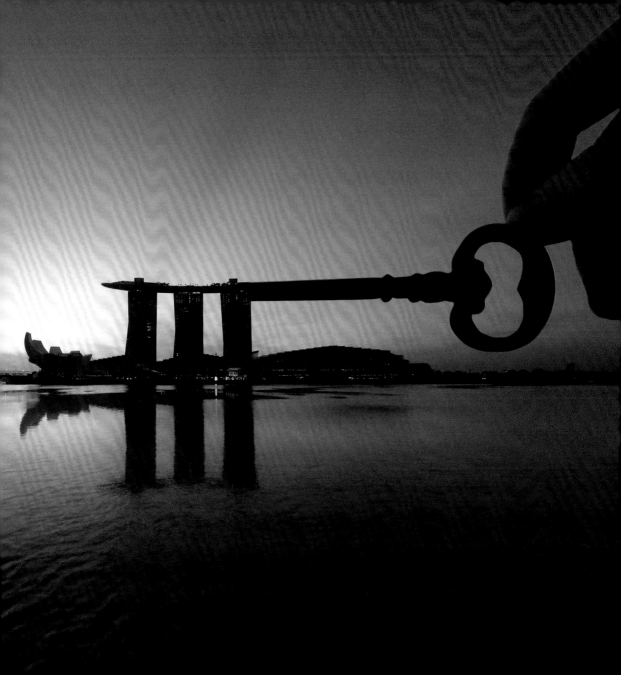

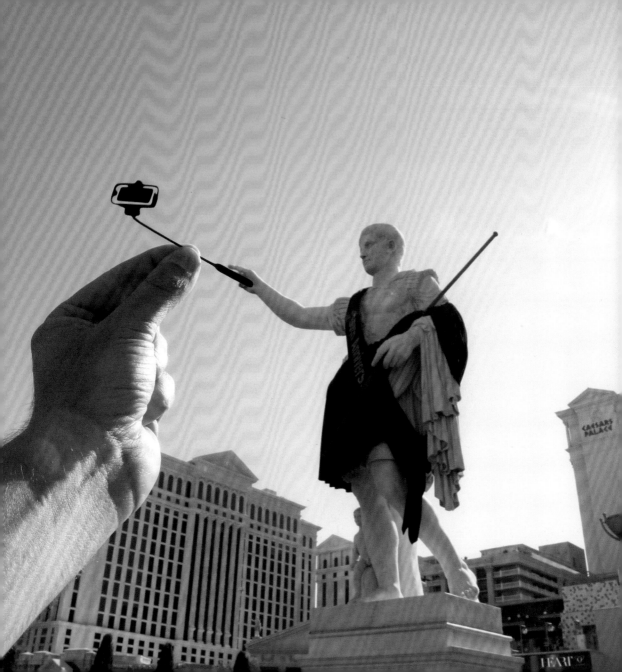

'Caesar the moment!'

CAESAR'S PALACE HOTEL

Las Vegas, Nevada, USA

POP CULTURE

Manhattan, New York, USA

EMPIRE STATE BUILDING

There was one photo that I just had to do when I was in New York...

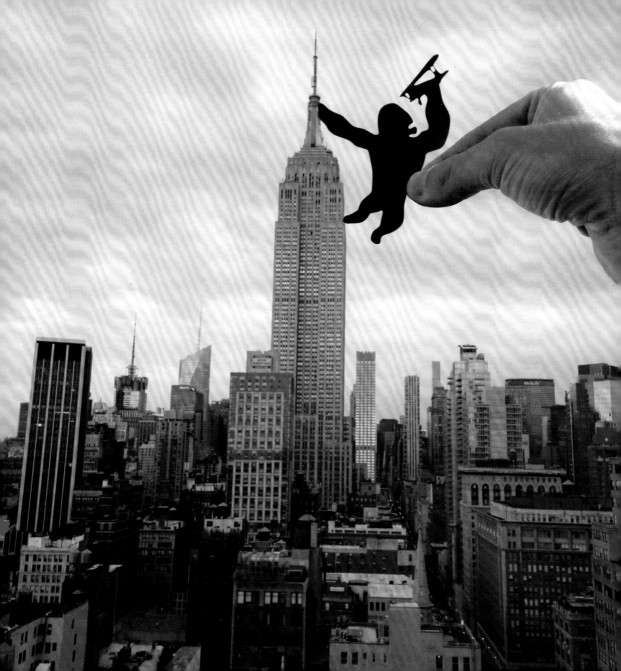

Las Vegas, Nevada, USA

NEON MUSEUM

This museum in downtown Vegas is an incredible step back into history – a neon boneyard filled with vintage signs from long-gone hotels and businesses.

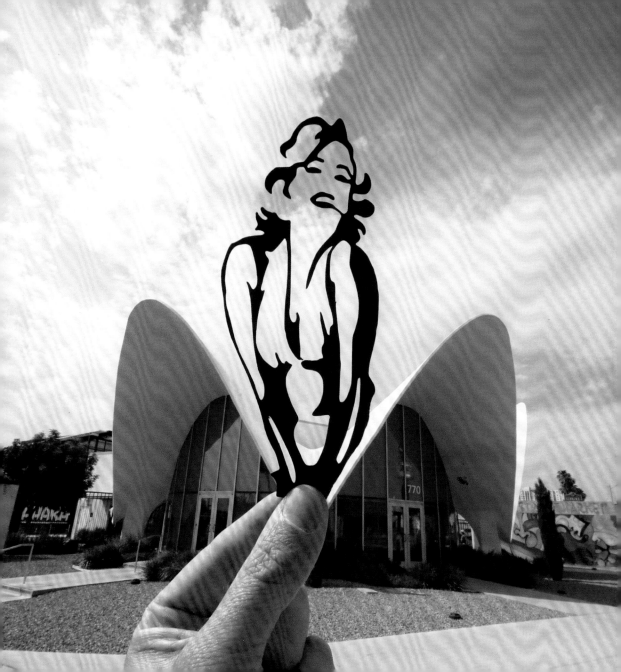

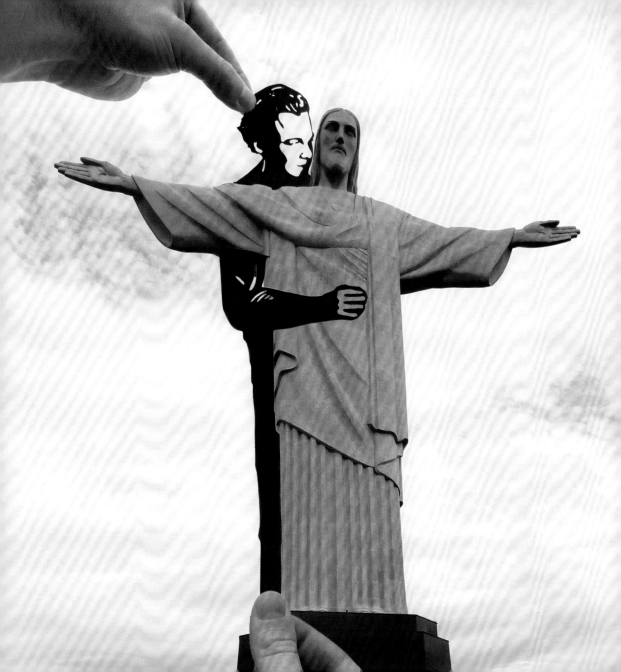

'I'm flying, Jack!'

Corcovado Mountain, Rio de Janeiro, Brazil

'CHRIST THE REDEEMER'
by Paul Landowski (face by Gheorghe Leonida)

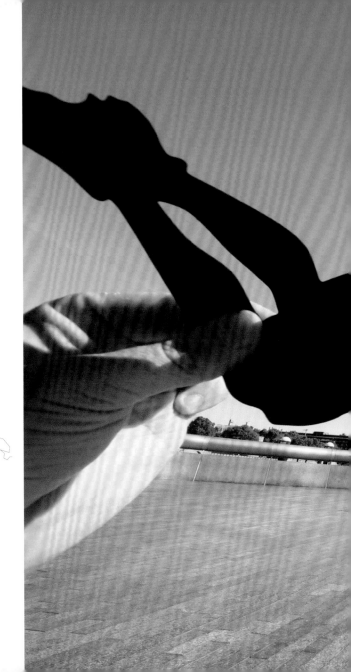

London, UK

CITY HALL

Fun fact: the technical name for the shape of an American football is a prolate spheroid.

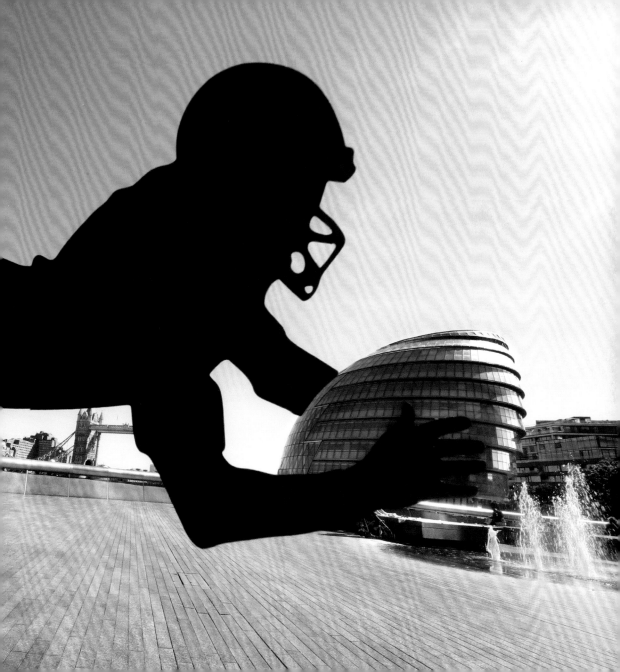

Dubai, United Arab Emirates

DUBAI OPERA HOUSE

Occasionally I'm asked, 'Why don't you Photoshop out your hands?' Originally the reason was I didn't know how to. But also, charm is lost in perfection. Do you remember the early Wallace and Gromit animations when you could see the fingerprints in the clay? I loved the fact you could see someone was physically making it, and it made me appreciate the craft more.

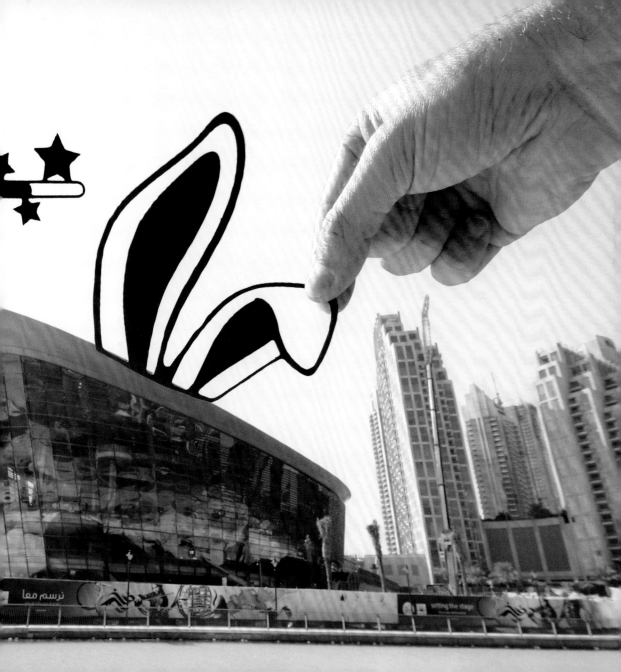

Sailing towards Toulon, France

✂

M.S. ROYAL PRINCESS

It doesn't take a genius to know that ice cream is always a good idea...

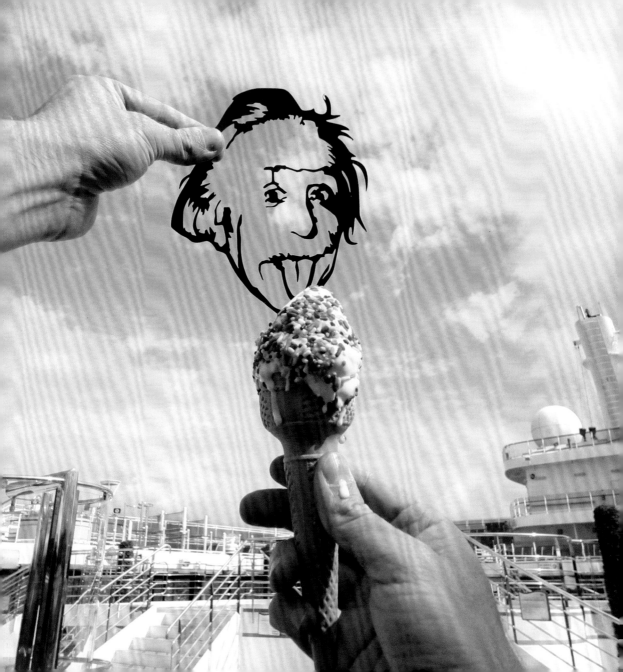

'I am the one who knocks.'

Walter White

Breaking Bad

Florence, Italy

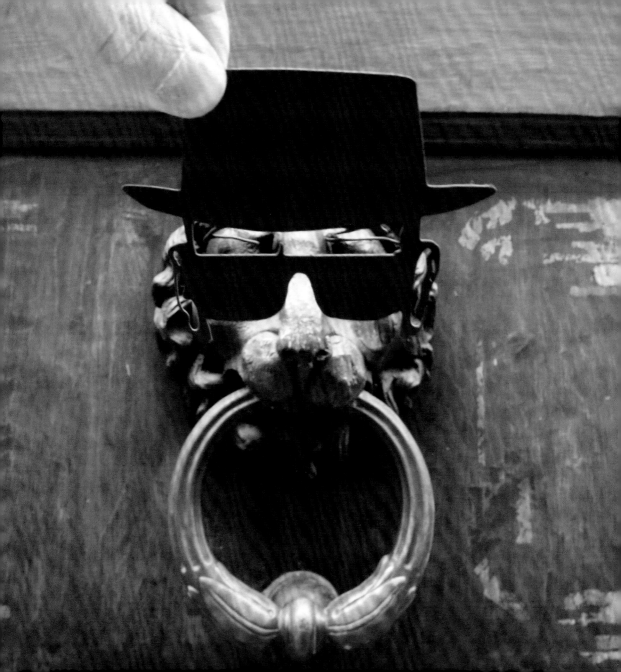

London, UK

LOVE LANE

If you venture to this street in London, you'll probably
encounter a pre-wedding photography shoot... or a guy
vandalising the street signs. Don't worry, my additions were
all made of paper.

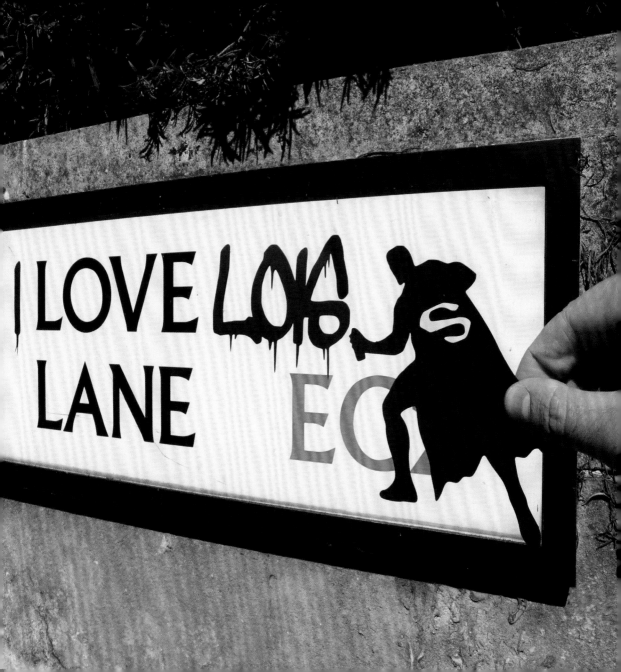

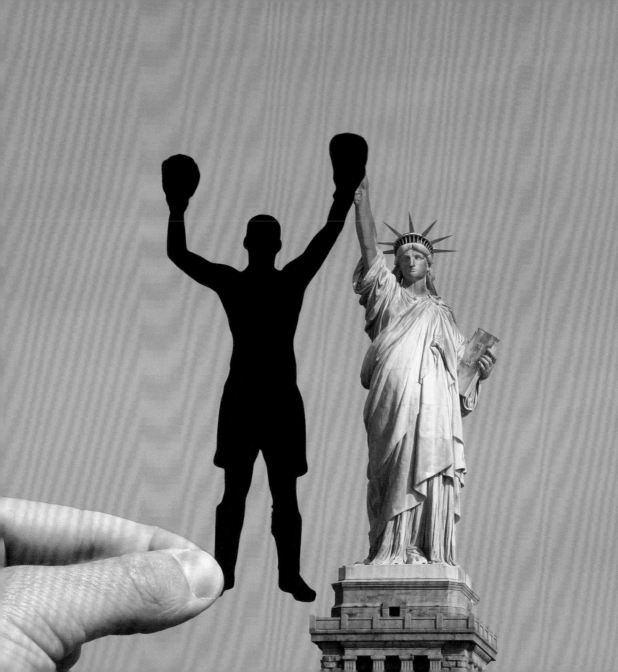

Liberty Island, Manhattan, New York, USA

STATUE OF LIBERTY

I was in New York the day that Muhammed Ali passed away, and that inspired two ideas with the Statue of Liberty. One of the ideas totally didn't work – see later for more on that – and then there was this idea.

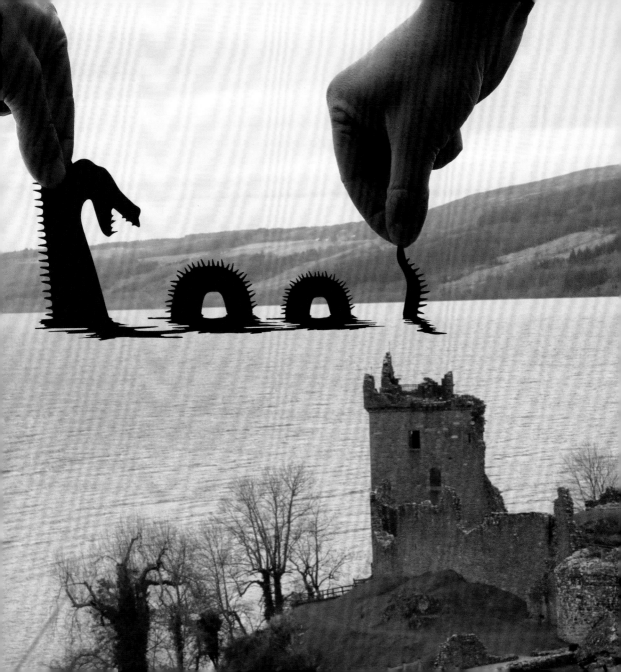

URQUHART CASTLE

This castle sits alongside the vast waters of Loch Ness. Around 225m deep, the loch is home to more water than all the lakes and rivers in England and Wales combined. It's also home to one of the most famous legends in the world – the Loch Ness Monster. The first organised search for the monster was in 1934 when twenty men were paid £2 a day to be 'monster watchers'. Since then many people have searched, including Dr Rines (who helped locate the wreck of *Titanic*) and even Thatcher's government considered an official hunt involving bringing dolphins over from America to help look for it. The largest effort was in 1987, when a team of researchers spent £1 million on a search involving sonar and camera tech. Three of their sonar contacts showed a creature 'larger than a shark but smaller than a whale'. Whilst nothing has ever been confirmed, in 2005 one hundred athletes didn't leave anything to chance when they took part in the Scottish Triathlon. They were each insured for £1 million against bites from the Loch Ness Monster.

San Francisco, California, USA

DE YOUNG MUSEUM +
KIM KARDASHIAN MASH-UP

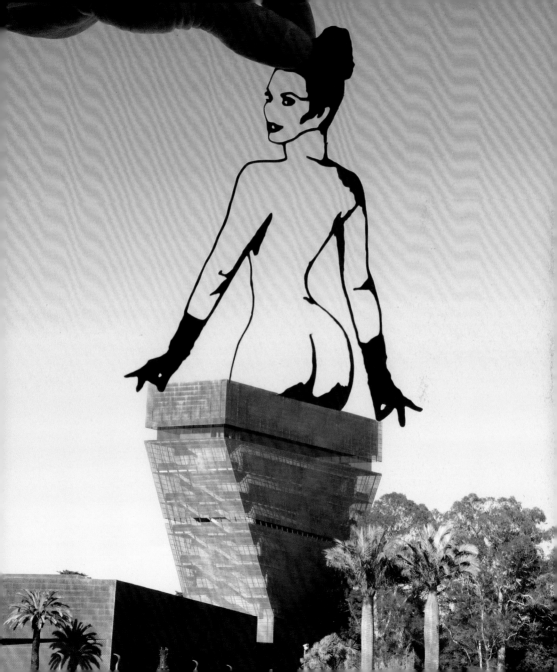

'Live long and prosper!'

Mr. Spock

Star Trek

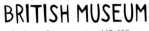

London, UK

BRITISH MUSEUM

Reclining Dionysos, circa 447–432 BC

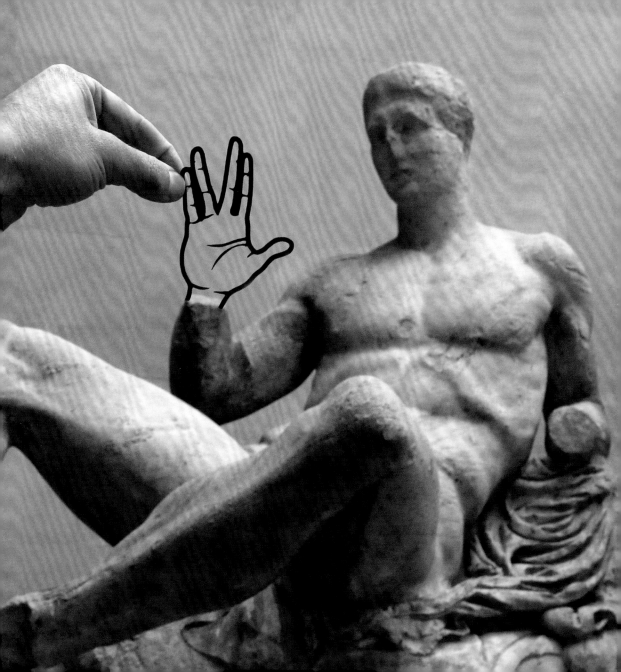

Versailles, France

HALL OF MIRRORS

If there's one place to prove that vampires have no reflection, it's here in the Palace of Versailles.

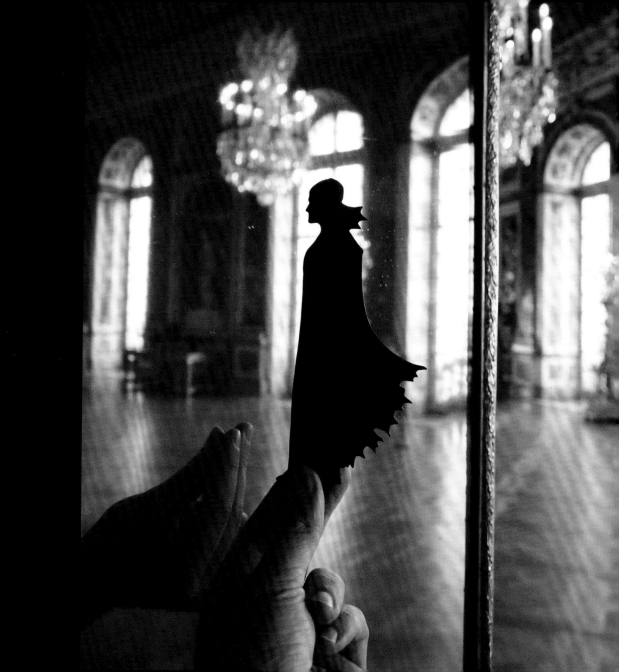

QUIRKY ARCHITECTURE

TRANSAMERICA BUILDING

The Gold Rush of 1848 brought thousands to the West, many arriving by ships, which were left abandoned in the harbour. San Francisco needed land to accommodate the growing population, so the nicer ships were turned into hotels and cafés and the rest were purposefully sunk for landfill. As the city expanded into the bay, many of the floating buildings found themselves surrounded by land, sitting along city streets. In 1851 a blaze ripped through the city destroying around twenty blocks and so the ships were forgotten and built over as the city was renovated. But in 1994, workers from the Muni Metro were digging a rail tunnel when they hit a ship. The vessel was so huge they literally had to tunnel through. Now, thousands of riders on J, K, L, M, N and T trains unknowingly ride through its hull every day.

West Hollywood, California, USA

PACIFIC DESIGN CENTER

I got locked out on the rooftop car park for this shot. It was worth it,
though, because this is one of my favourite images.

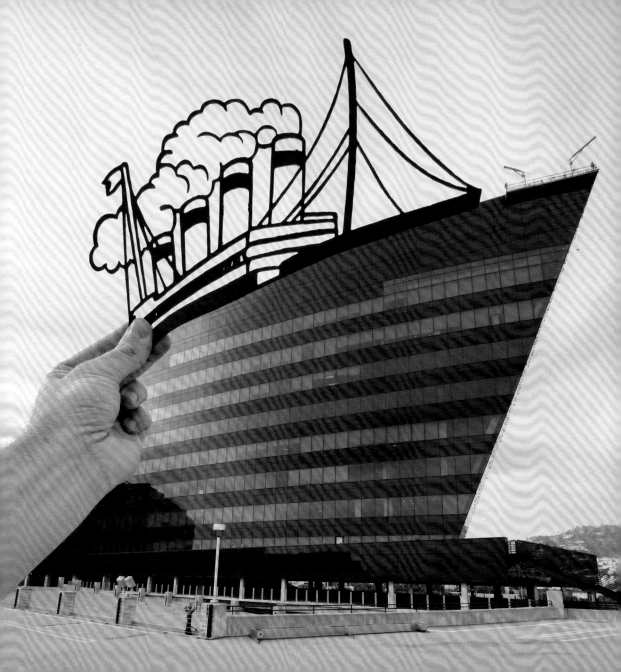

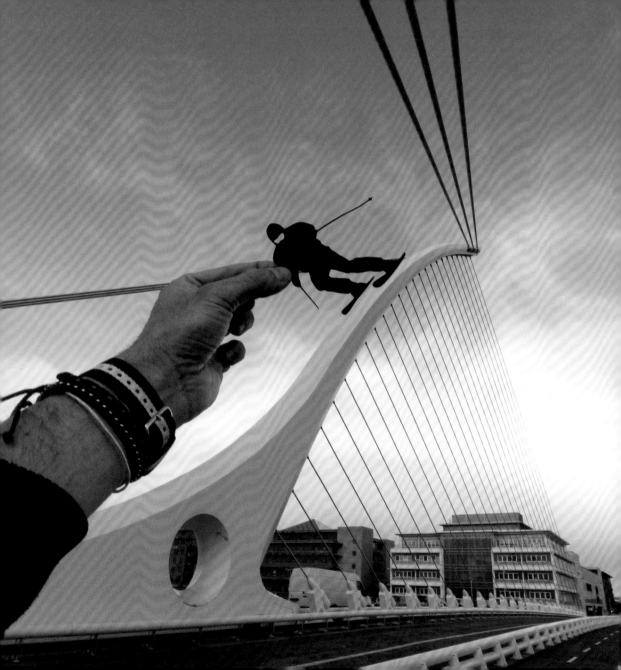

Dublin, Ireland

SAMUEL BECKETT BRIDGE

There is a tale of a wealthy man named Buck Whaley who lived here back in the 1700s. He made a bet to a friend that he'd be buried on Irish soil, but when he gambled away his wealth, he had to leave Ireland because of his debts. After his death, he was buried in the Isle of Man. However, he didn't lose the bet – before he died he imported a shipload of Irish soil for his final resting place.

London, UK

20 FENCHURCH STREET

The original plans for this building stated that it would reach 220m in height. However, due to concerns over its impact on the views of St Paul's Cathedral, the plans were reduced. So one of the reasons why the tower has a stubby look, is that the designs were altered to create more capacity, leading to the architect disowning the project.

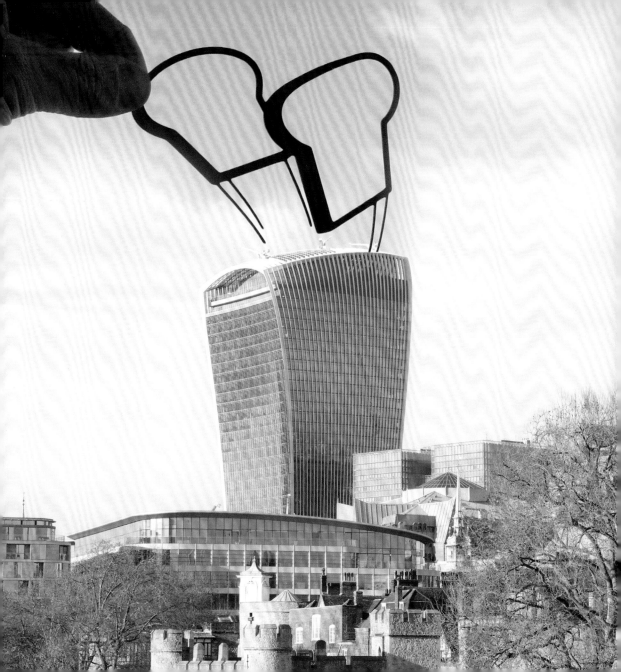

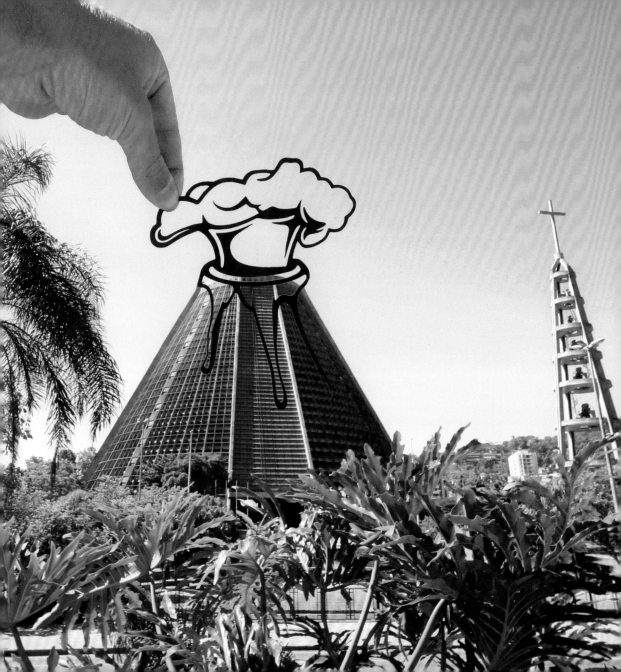

Rio de Janeiro, Brazil

METROPOLITAN CATHEDRAL

The cathedral was designed by architect Edgar Fonseca, who intended the modern temple to look like an ancient Mayan pyramid in the middle of a modern city. 20,000 people can fit inside and there's even a museum in the basement – a much more efficient use of space than the Mayans achieved.

Amsterdam, The Netherlands

ZAANSE SCHANS

During the first half of the twentieth century, North Amsterdam
was industrialising rapidly and much of the city's characteristic
architecture was falling victim to the city's expansion. So during the
1950s, dozens of the remaining farms, houses and windmills from
the local area were broken down, carted off and reassembled here
in Zaanse Schans to preserve a snippet of Dutch culture in a sort of
traditional village.

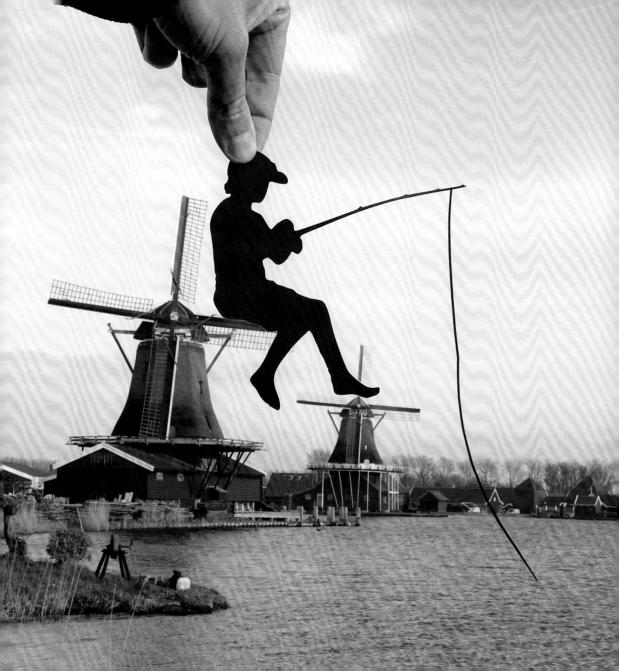

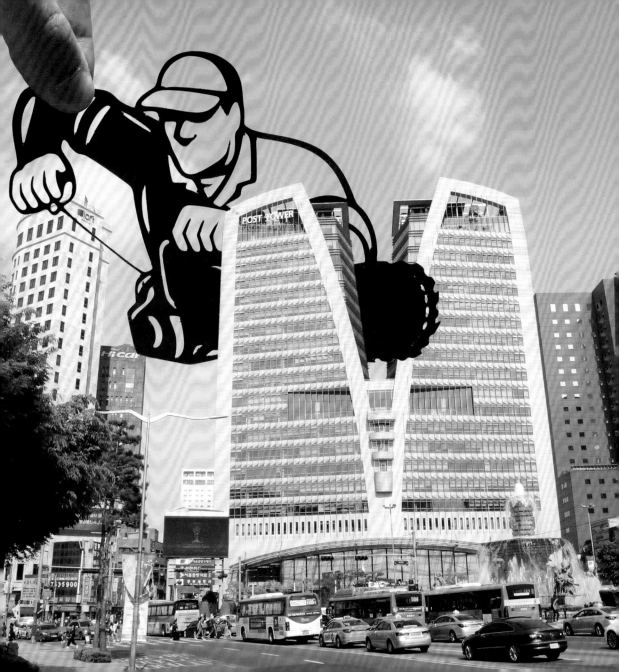

Seoul, South Korea

CENTRAL POST OFFICE

As well as coming up with ideas for cut-outs, much of my time involves experimenting with vantage points to discover which gives the cut-out the most convincing effect. It took six different locations and hundreds of photographs of the Seoul Central Post Office before the sense of perspective was just right. Photography certainly teaches patience...

Singapore

SUPERTREE GROVE

If you fly into Singapore you may notice
a number of bizarre structures that sort
of look like oversized golf tees reaching
25-50m in the air. They're Supertrees.
Like real trees they can photosynthesise
and absorb rainwater. But unlike real
trees, when the sun sets these trees put
on an epic light and sound show.

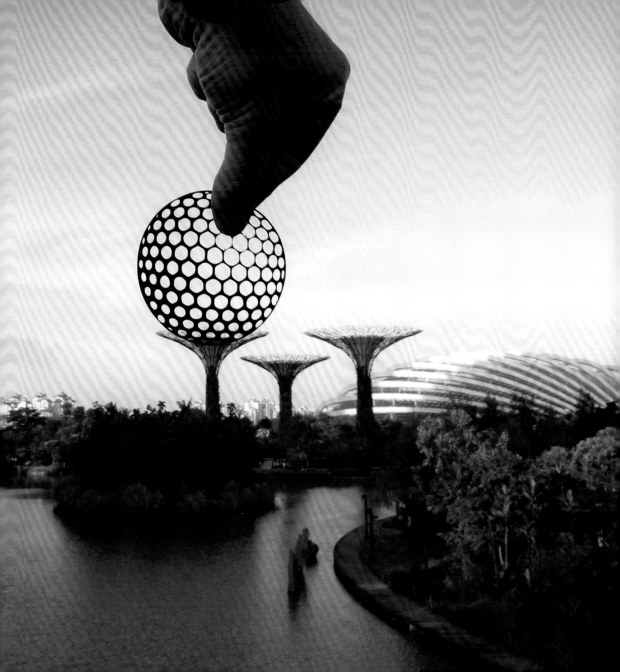

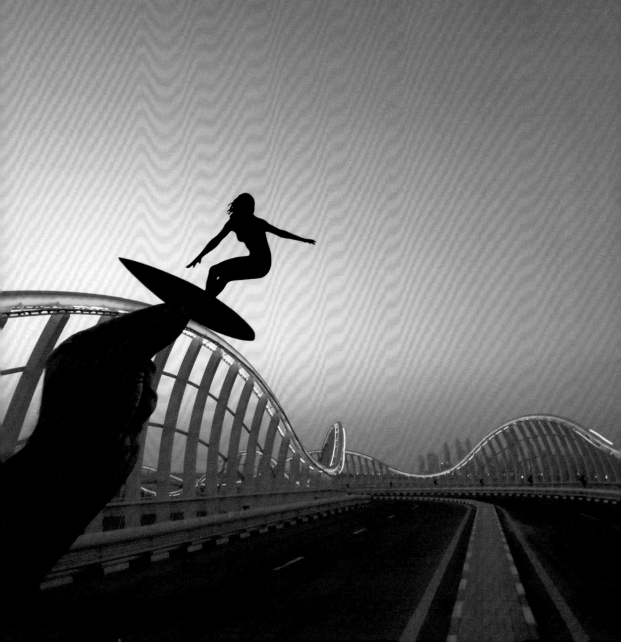

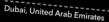

Dubai, United Arab Emirates

AL MEYDAN BRIDGE

I found out about this bridge when I saw the video of YouTuber Casey Neistat skateboarding here behind a Lamborghini. However, Casey was made to delete most of his footage by security, so I was in full-on stealth mode when I got here. Sure enough, within two minutes of arriving there was a honk behind me – a security car. It pulled up beside me and the guard (very politely) told me that I shouldn't be taking photos here. I showed him what I was doing with the surfer cut-out and I could see a slight smile grow on his face. He then said, 'I'm going to drive around one more time and then I'll give you a ride to the nearest taxi rank.' So in the end I got my shot and I got a lift. I'd call that a success.

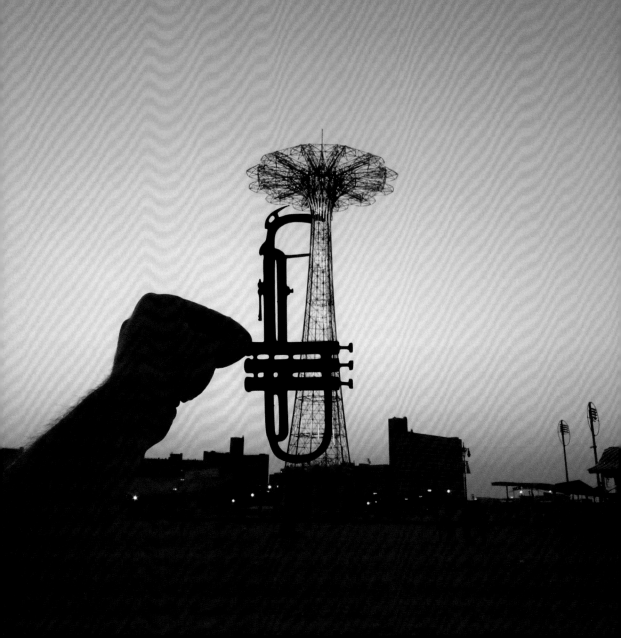

Brooklyn, New York, USA

CONEY ISLAND PARACHUTE JUMP

When it opened by the boardwalk in 1940, the parachute jump was designed to simulate the experience of falling to earth in a parachute, but it struggled to make money. So the operators came up with an idea: they offered free rides to young women who looked like 'screamers'. They'd then purposefully strand the ladies in mid-air during the descent so they, as expected, would scream in terror. Totally cruel, but for a while it did help to attract the crowds. However, even these marketing tactics weren't enough, and combined with the fact that the ride often had to shut due to wind, it closed forever in 1964. Since then the tower has suffered abandonment, planned demolitions, fires and Hurricane Sandy, but it's still here – a series of feats worth blowing its own trumpet about, I reckon.

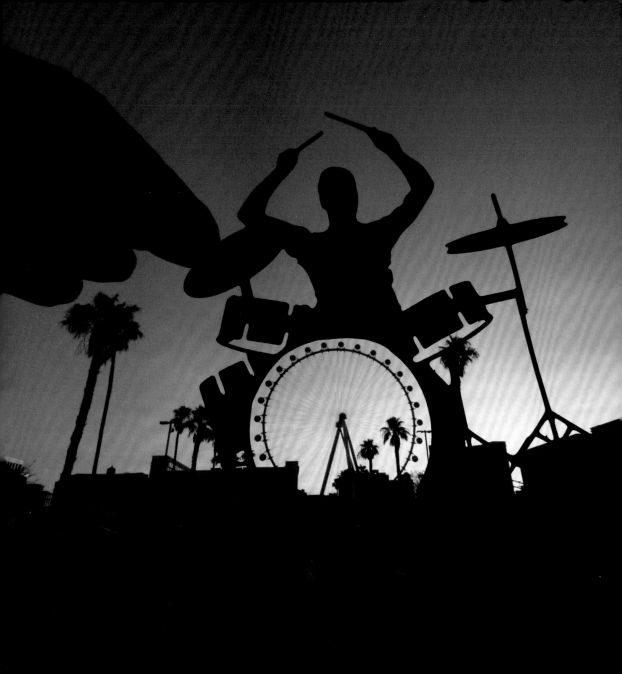

Las Vegas, Nevada, USA

HIGH ROLLER FERRIS WHEEL

Currently the world's tallest ferris wheel, it's 2.7m taller than the 165m Singapore Flyer, which had held the record from 2008. At the time of writing this, though, the Ain Dubai on Bluewaters Island in Dubai intends to thrash the record and rise to 210m tall.

Paris, France

CINÉMATHÈQUE FRANÇAISE

Some of the greatest treasures in the history of cinema are inside
this unusual-looking building in Paris. There are seventeenth-century
optical boxes and magic lanterns, but also costumes worn by
Hollywood legends, original posters, studio scenery, and even the
head of Mrs Bates from *Psycho*.

'Well, one of us has to go home and change.'

JUMEIRAH EMIRATES TOWERS

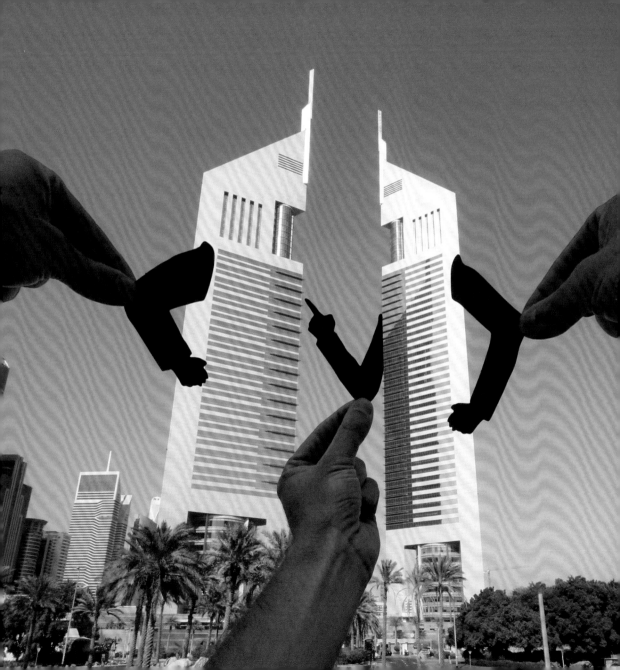

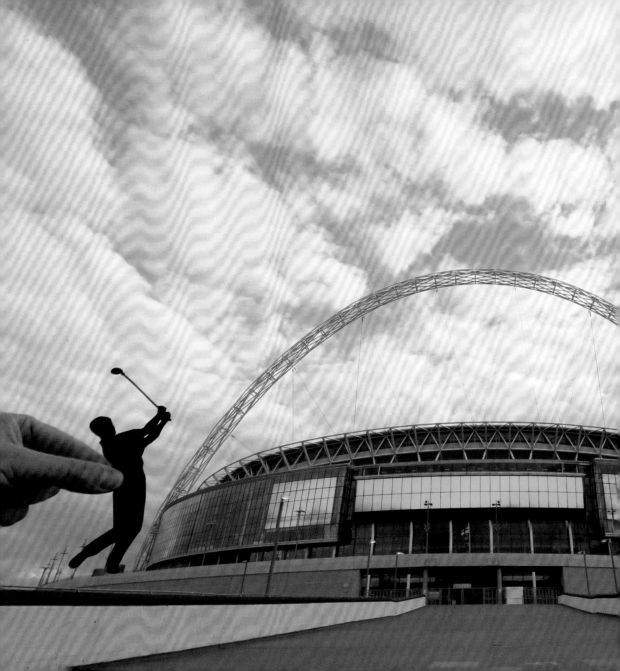

WEMBLEY STADIUM

The stadium's pitch features something called DESSO technology, which combines synthetic grass with real Wembley grass to give it more durability. This is why Wembley can consistently provide a quality playing surface for football, rugby, American football and other events. It's also the same technology that's used on a number of golf courses around the world.

London, UK

JUMEIRAH BEACH HOTEL

From the front this hotel is designed to look like a wave to complement the sail design of the nearby Burj Al Arab, so from the right vantage point you get a pretty cool effect of a sailboat and a wave beneath it. That would have been too easy to do a cut-out with, though...

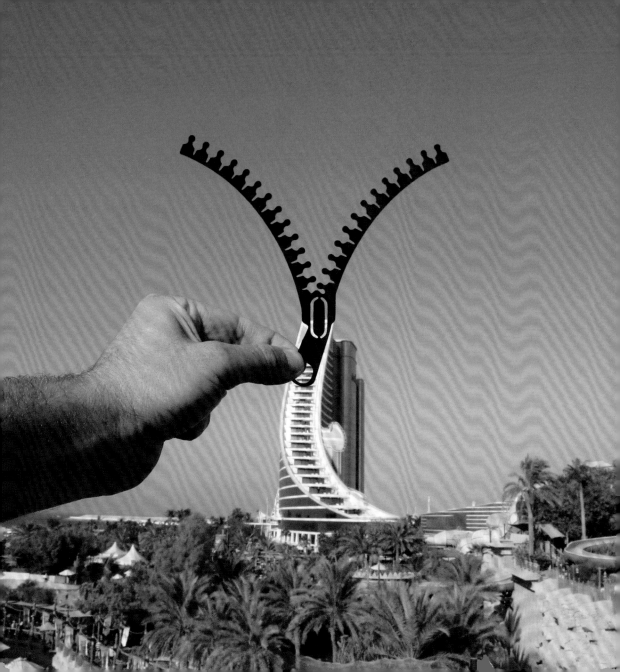

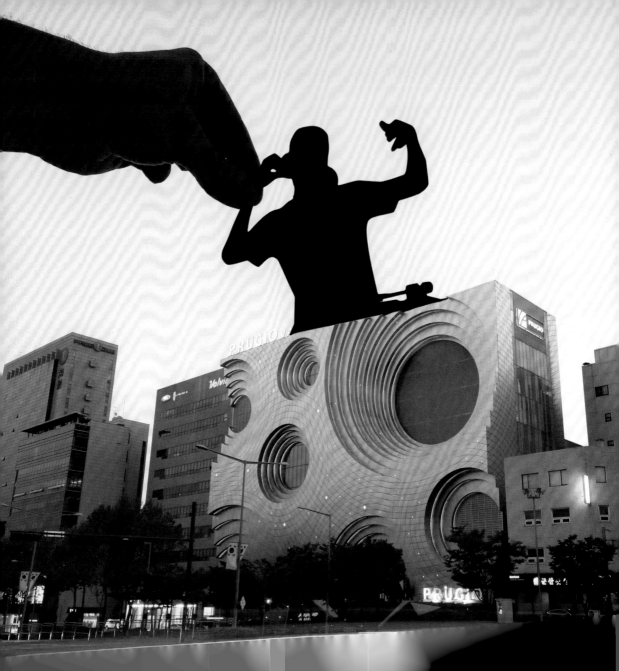

Seoul, South Korea

PRUGIO VALLEY

Sometimes it feels like buildings were designed with me in mind, as if the architects knew that I wouldn't be able to resist embellishing their quirky designs...

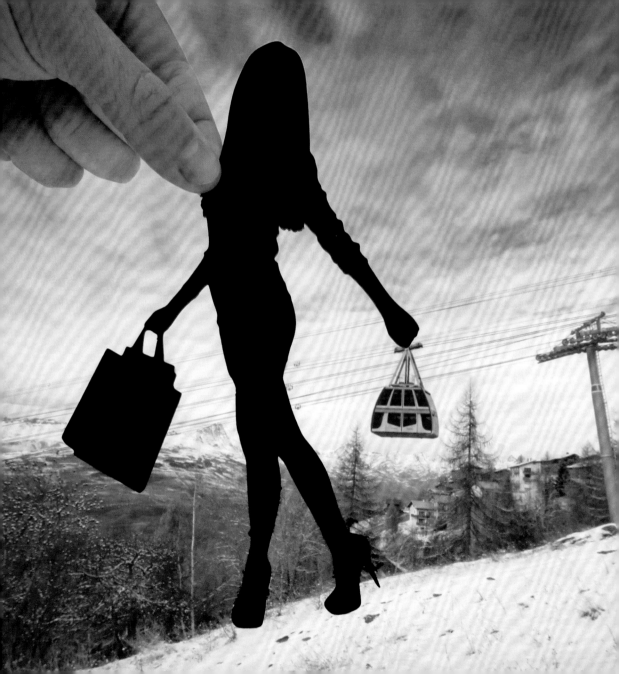

Auvergne-Rhône-Alpes, France

VANOISE EXPRESS CABLE CAR

This often features in lists of the best cable car experiences in the world due to its views over the endless mountains around it. When it opened it was officially the biggest, longest and fastest cable car anywhere, but since then a few others have taken that title.

SCIENCE PARK

Before I travel somewhere, I'll try and do as much
research as I can about the local landmarks and
architecture (as well as any bizarre or unusual
things to see). I'll then doodle ideas until I come
up with something that makes me laugh to myself.
Sometimes it can take a while and other times, like
with this one, I'll have the idea almost immediately.

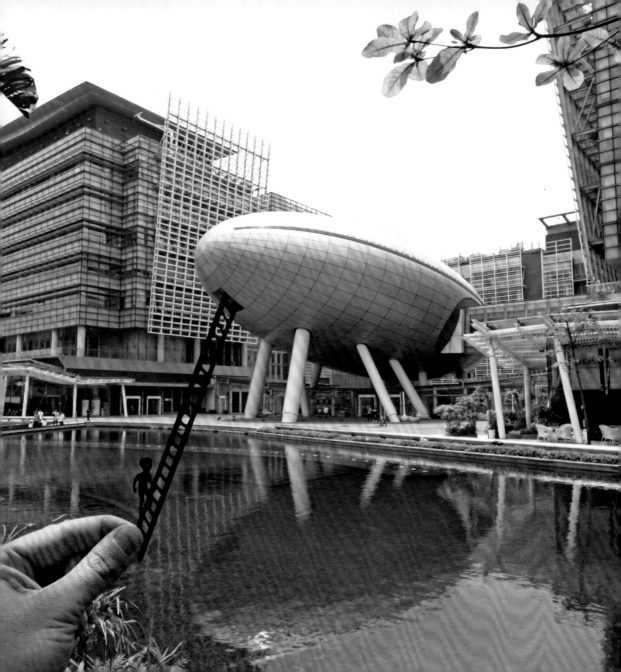

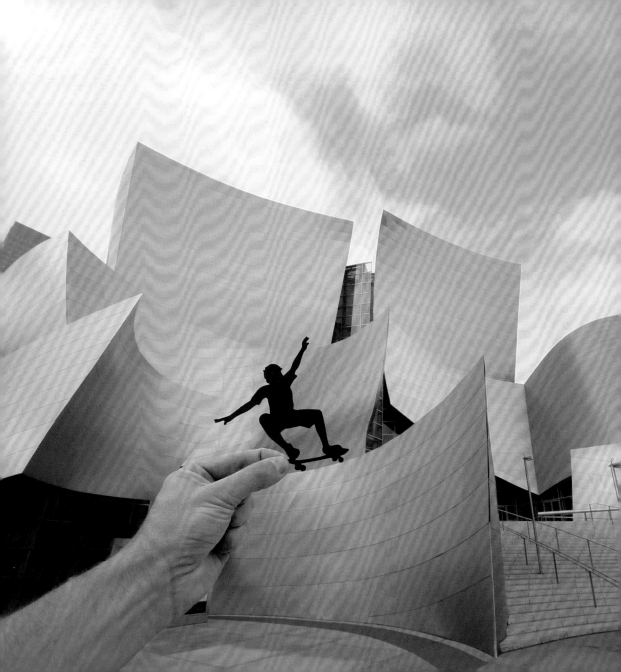

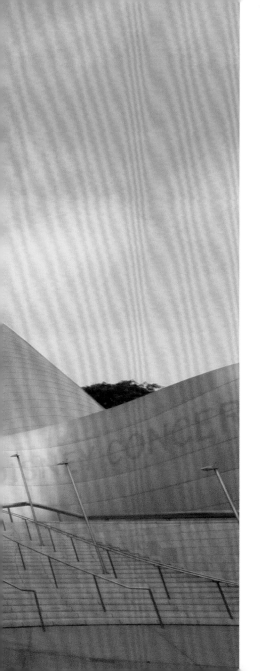

WALT DISNEY CONCERT HALL

When L.A. mayor James Hahn dedicated this building he jokingly said, 'This place really gleams, doesn't it? I think it's got a UV factor of 100.' Turns out he wasn't kidding; the people living in the adjacent building suddenly found themselves in overheating apartments and saw their air-conditioning fees skyrocket. Traffic cones were melting in the street and the glare was so bright it even distracted drivers on the 101 Freeway, so in 2005 a study was commissioned to figure out what exactly was going on. It was discovered that the combination of hyperreflective steel and the concave surface design created a parabolic mirror effect that was creating a microclimate with temperatures soaring to 60°C on the sidewalk. The offending steel panels were identified and then sanded down to reduce the reflection.

SOLOMON R. GUGGENHEIM MUSEUM

Some of Frank Lloyd Wright's original concepts for the museum included a super-fast glass-tube elevator that would whisk visitors up to the top of the building in moments and an automatic vacuum system in the lobby to constantly clean the dirt brought in by visitors. According to Wright's widow, he had become increasingly frustrated by the compromises he had been forced to make, and although he passed away before the New York Guggenheim opened, she suspected he wouldn't have attended the opening anyway. However, if you ever visit the Guggenheim Museum in Bilbao, Spain (designed by Frank Gehry), you'll notice that there is a very modern-looking glass-tube elevator in there. I like to think this was Gehry's way of bringing at least one of Wright's crazy ideas to life.

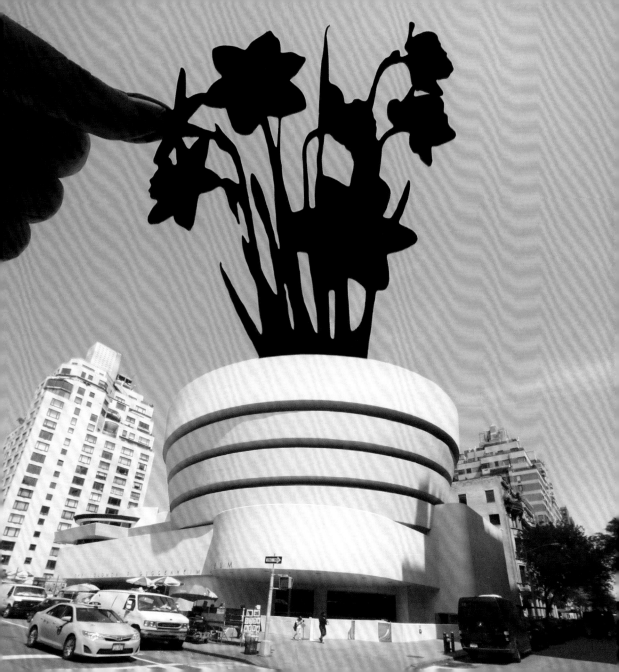

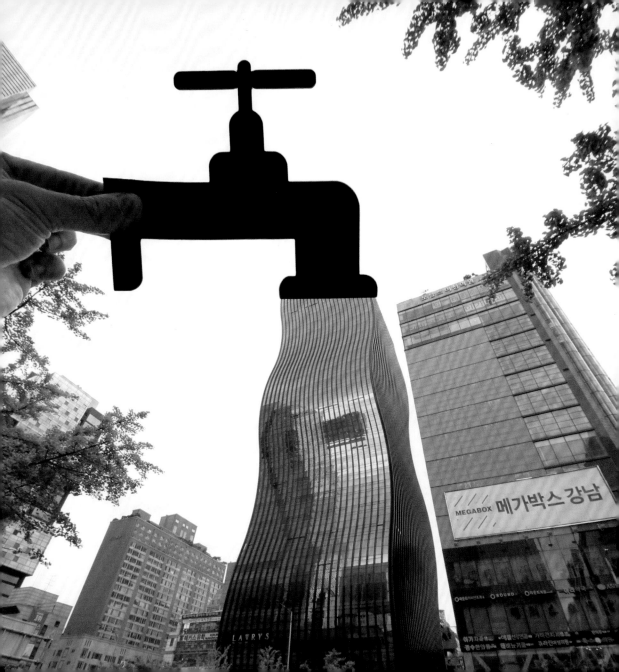

Seoul, South Korea

SEOCHO GARAK TOWER

As I have become more fascinated with architecture, the more
I appreciate designs that push the boundaries. The glass facade on
the Seocho Garak Tower looks like undulating waves and, because
the reflections on the glass change with the light, it conjures a
surreal effect of motion.

Dubai, United Arab Emirates

CAYAN TOWER

This is the world's tallest twisted tower. Fortunately, I happened to be carrying the world's longest spanner with me at the time to get this photo.

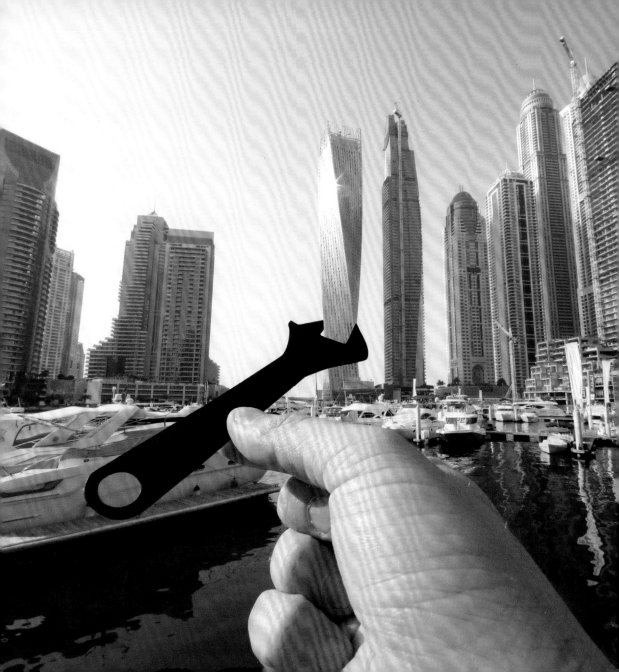

Belfast, Northern Ireland, UK

'RISE'

by Wolfgang Buttress

Price & Myers, the engineering firm behind this sculpture, based their designs on 'geodesic geometry'. So 2,421 steel tubes, 804 bolted joints and 21 carefully positioned legs later, the effect is two spheres, one inside the other, that hover in the middle of Belfast.

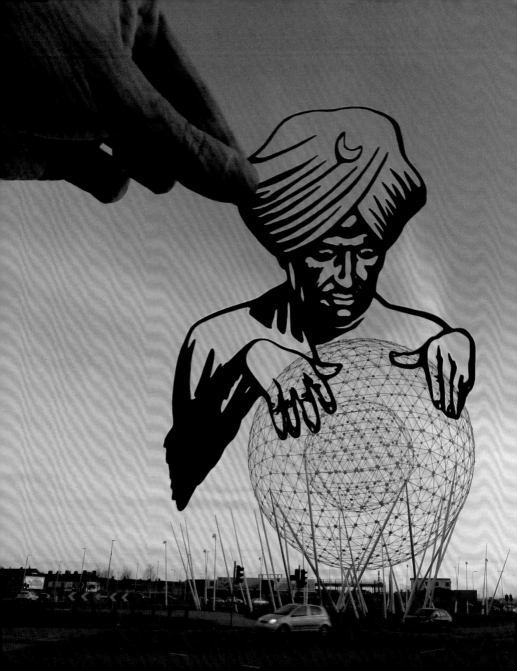

RIVER THAMES

This is probably one of my favourite vantage points in London.
I've been here on numerous occasions to watch the sunrise
through my viewfinder as Tower Bridge, The Shard and the
Millennium Bridge turn from silhouettes in the dark to beautifully
lit landmarks.

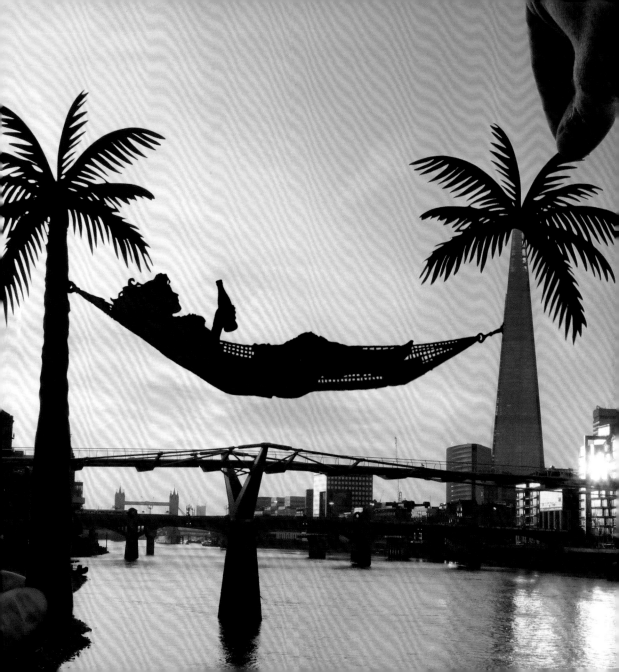

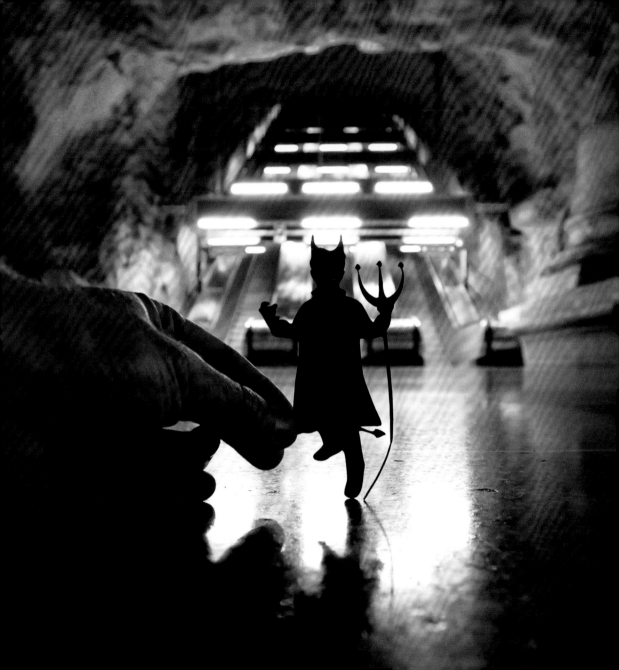

Stockholm, Sweden

RÅDHUSET METRO STATION

The metro stations in Stockholm are incredibly designed – many of them have their own theme, which makes the whole thing like a 110km art exhibit.

PLAYING WITH FOOD

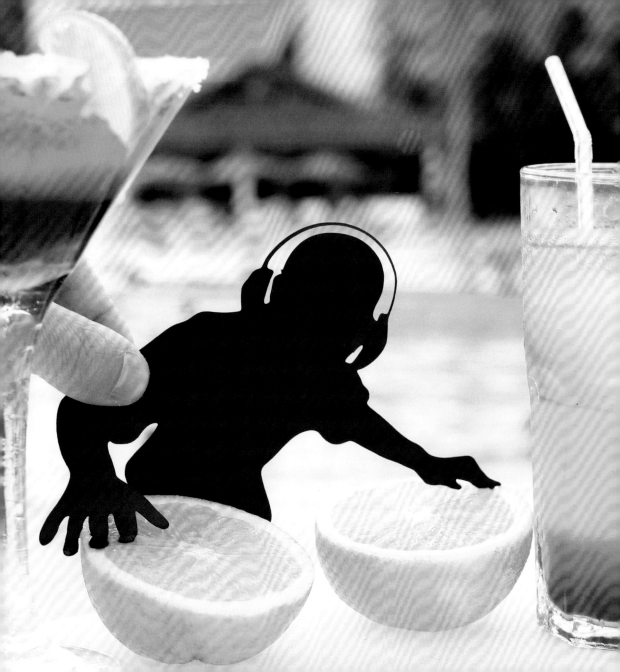

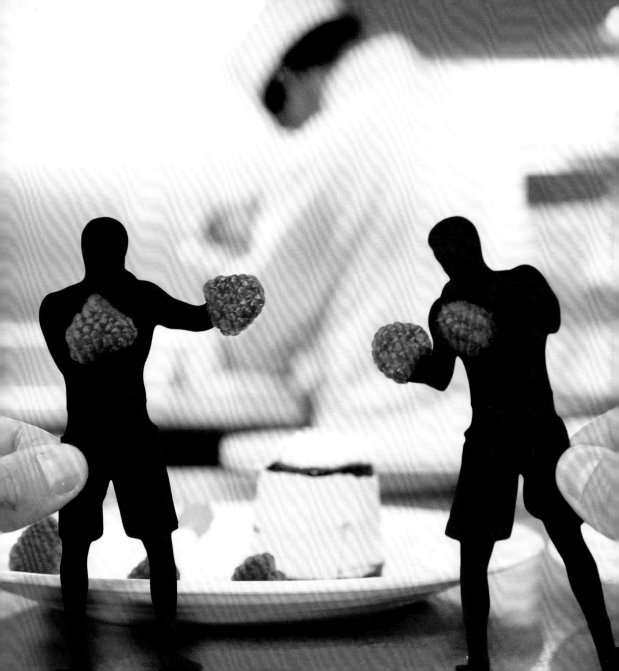

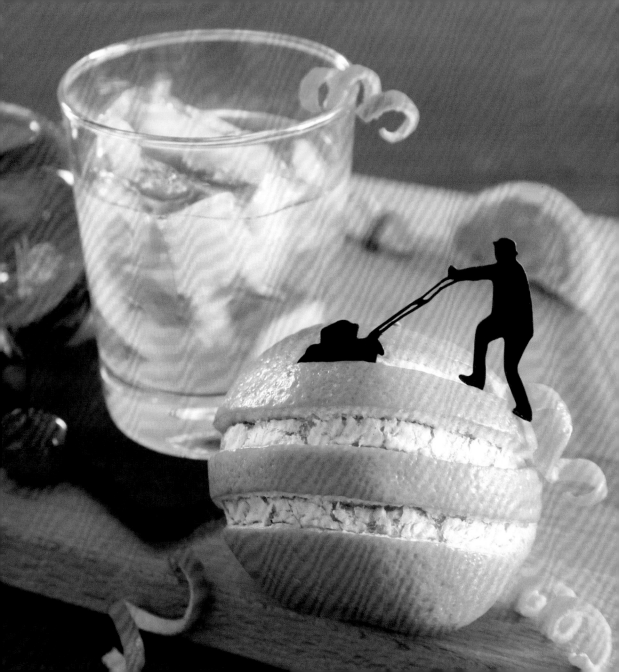

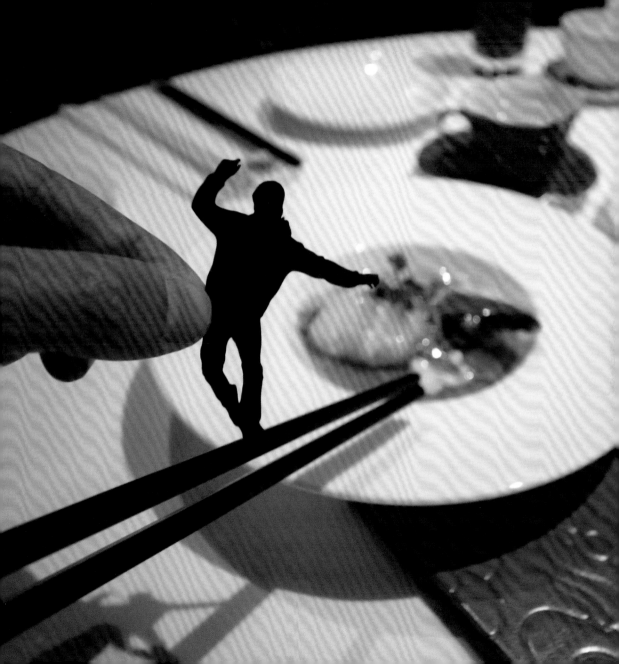

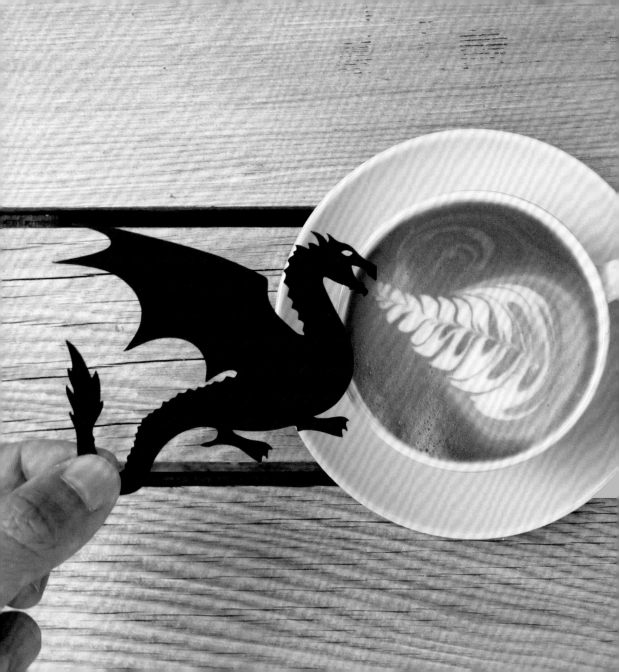

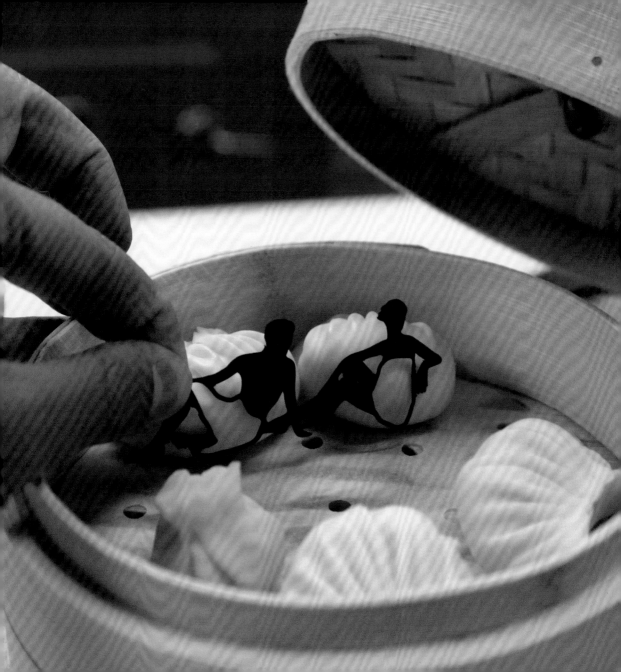

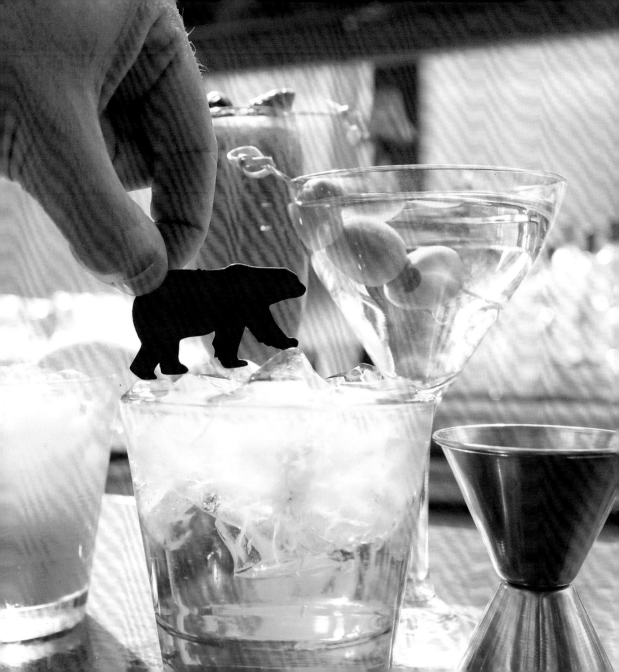

Rio de Janeiro, Brazil

✂

RIO DAS PEDRAS

One of my early ideas was to take a photo of a whale tail in every pool, lake and sea that I visited. I eventually developed the design to include the splash and ripples to bring it to life a little more (rather than asking my friends to jump and splash around as I took the photo).

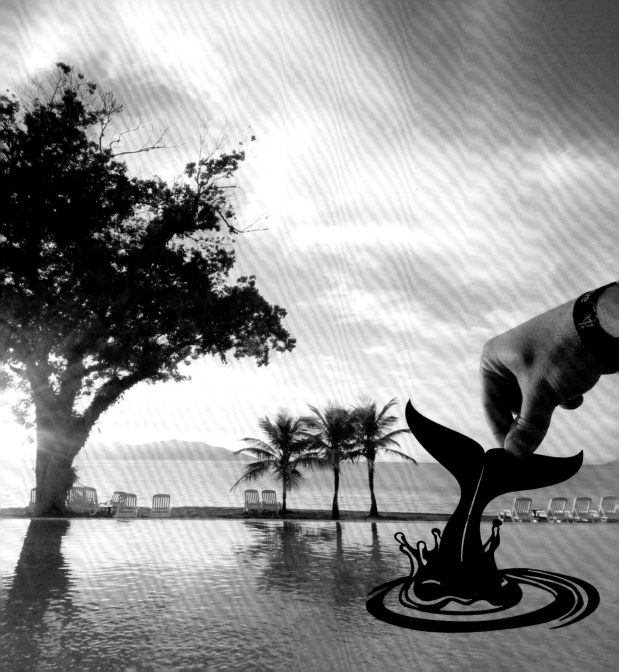

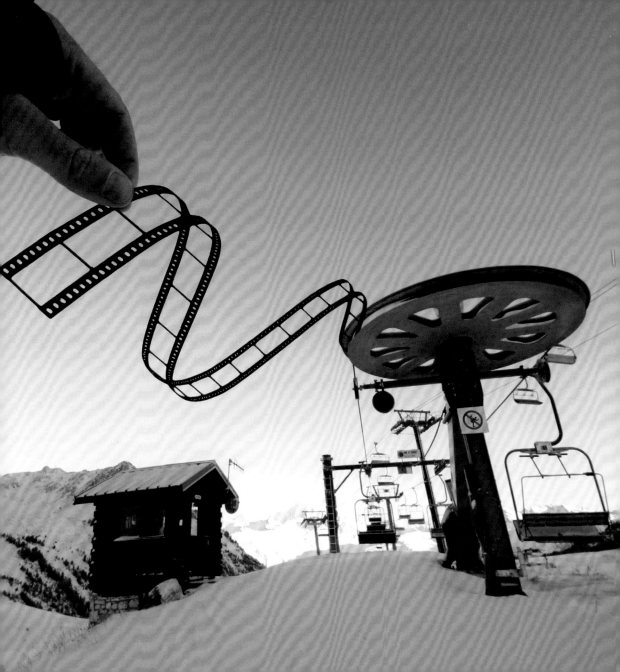

Auvergne-Rhône-Alpes, France

VAL D'ISÈRE

There's one question everyone asks me: 'How do you come up with your ideas?' I often just smile and say, 'I don't know,' but truthfully nothing comes from nowhere. When I used to work in TV, I remember the office had film reels tucked away in a corner, and we had to throw them out one day. I remember unspooling them and I wouldn't be surprised if in some way that memory inspired this idea.

'Say Ahhh'

Paris, France

RIVER SEINE EMBANKMENT

T-Rex sculpture by Philippe Pasqua

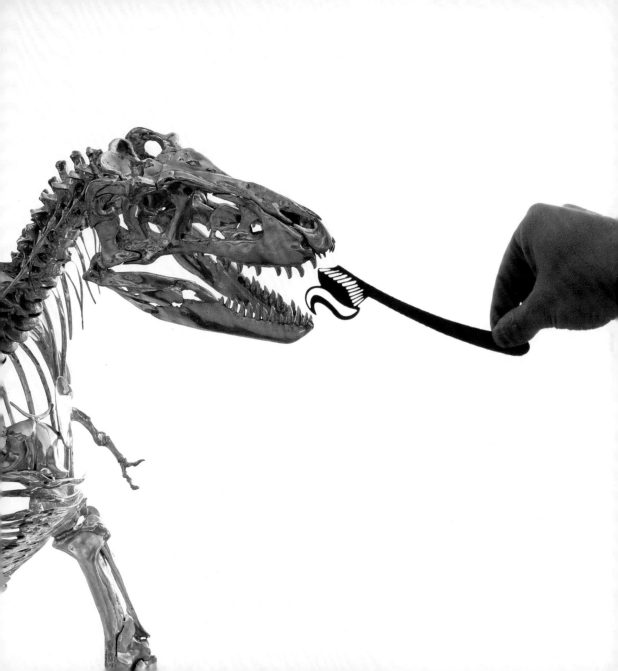

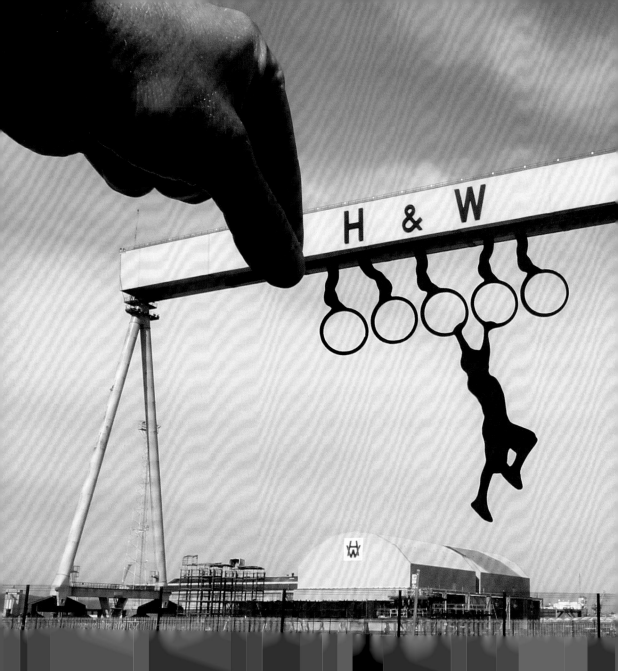

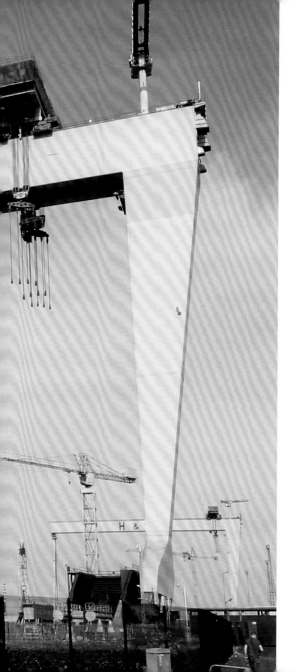

Belfast, Northern Ireland, UK

HARLAND & WOLFF SHIPYARD

These gigantic cranes, known as Samson and Goliath, are in the Harland & Wolff shipyard, the same shipbuilding company that built *Titanic* just a few hundred metres from here.

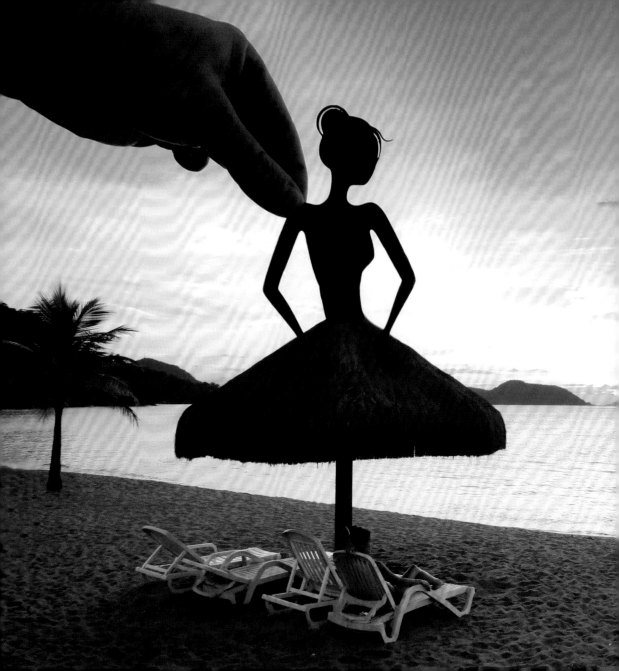

Rio de Janeiro, Brazil

RIO DAS PEDRAS

I've seen some of the very best sunrises in the world from the beaches of Brazil.

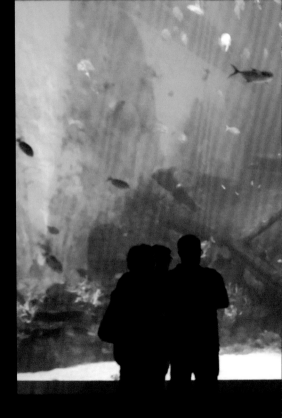

Singapore

S.E.A. AQUARIUM

At the moment Singapore relies
heavily on its neighbouring
countries for its fresh water
supply, so the government has
invested in an incredibly clever
technological process (which
features words like *microfiltration*
and *reverse osmosis*...) to purify its
waste water. You can buy a bottle
of it in the shops in Singapore; it's
called NEWater and it's arguably
some of the purest water you
can buy anywhere in the world.
It's part of a plan to achieve
sustainable fresh water before
the water supply from Malaysia
contractually expires in 2061.

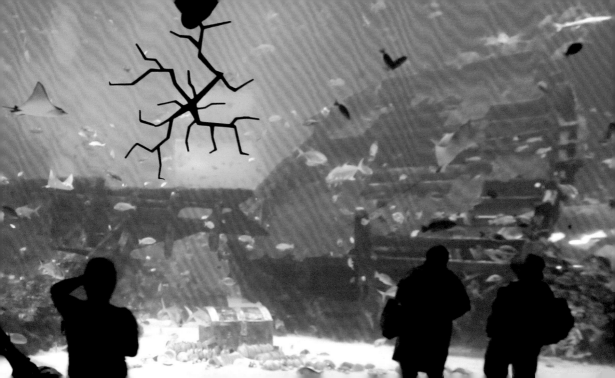

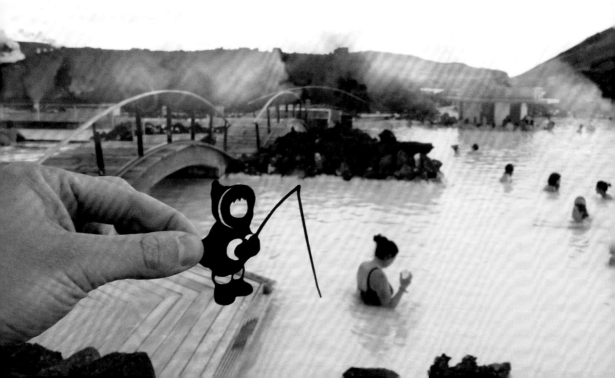

Reykjavik, Iceland

BLUE LAGOON

I took this shot whilst exploring the incredible landscapes in Iceland, where folklore is very much alive. Dotted around the island are clues that local legends are still respected: roads split into two then reunite to avoid a sacred spot; building projects are terminated when deemed to disturb the homes of the *huldufólk* (hidden people); and on the lips of the locals are tales waiting to be told about an acquaintance who once saw a strange creature. Ina landscape haunted by howling winds, boiling geysers and fiery eruptions, it's actually easy to imagine hidden people and strange creatures lurking behind waterfalls.

'Here, kitty kitty!'

Las Vegas, Nevada, USA

M.G.M. GRAND HOTEL

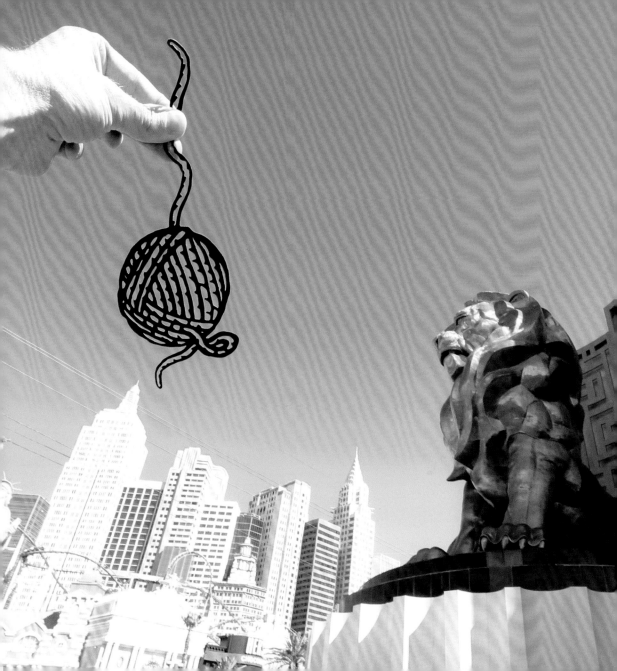

Seoul, South Korea

HEUNGNYEMUN GATE

Sometimes I'll have a concept for a cut-out in my head but I won't
necessarily know a building that it works with yet. In Seoul, I noticed
that when I photographed the roof of the Heungnyemun Gate
it created this sort of curved shape which gave me the perfect
opportunity to use this concept.

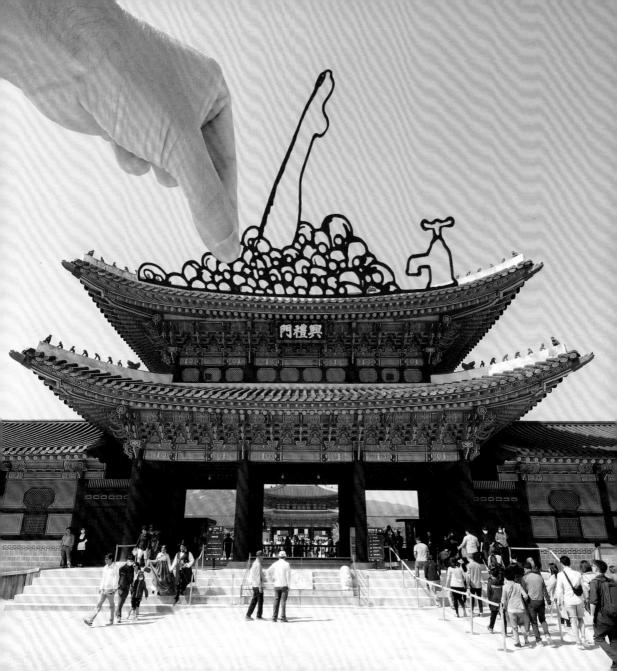

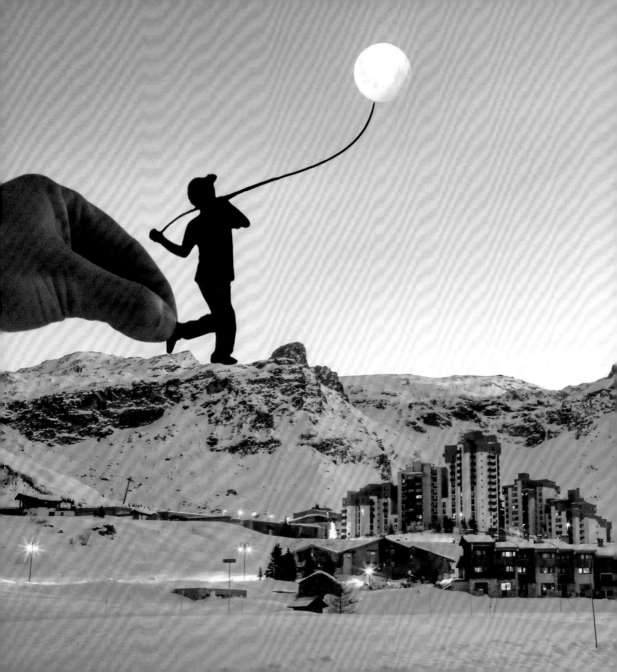

TIGNES

I was standing on the frozen lake that neighbours the town when I took this shot. A little further down the mountains there is another lake, where once every decade the waters are drained and the remains of an old village emerges from the icy depths. The village was purposefully flooded for the sake of a hydro-electric dam. In compensation, EDF (Electricité de France) rebuilt the village above the lake at Les Boisses, including an exact copy of the church. They even built a cemetery beside the church, exhumed the graves of those in the old village and re-buried them in the new cemetery. Here's the strangest part of the story though: ever since then there have been stories about ghostly figures wandering down from the new village into the waters of the lake as if they're searching for their original resting place...

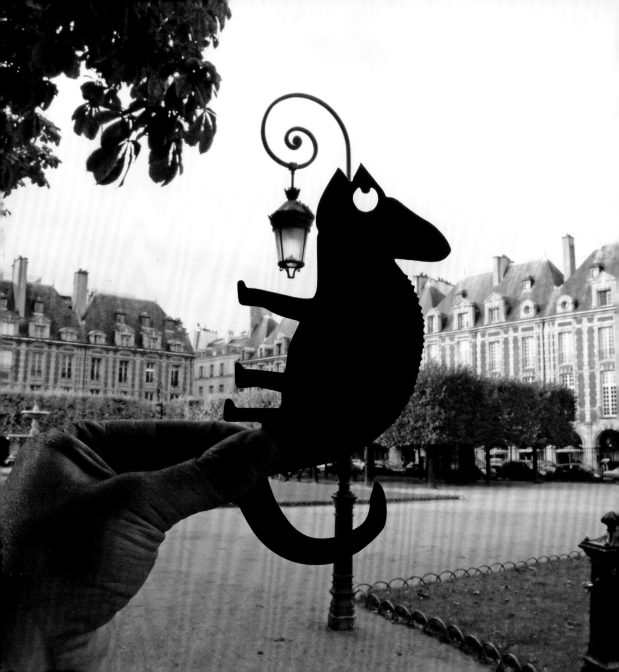

Paris, France

PLACE DES VOSGES

Paris is full of hidden gems and quiet squares. Every time I go back
I find something that inspires a new idea.

Auvergne-Rhône-Alpes, France

✂

VAL D'ISÈRE

I took this on a trip where I tried my hand at snowboarding. I found
out that snowboarding's popularity is somewhat thanks to James
Bond. Or, more specifically, thanks to Tom Sims, who was Roger
Moore's stunt double in *A View to a Kill*. In one action sequence,
Sims threw himself down a mountain on a snowboard whilst pulling
off impressive tricks in front of the camera. When the film came out
in 1985, sales of snowboards soared as the sport hit the mainstream.
It was a pretty good bit of PR by Sims since he owned Sims
Snowboards, one of the very few companies selling snowboards at
the time. I also threw myself down the mountain, but with none of
Sims' skill.

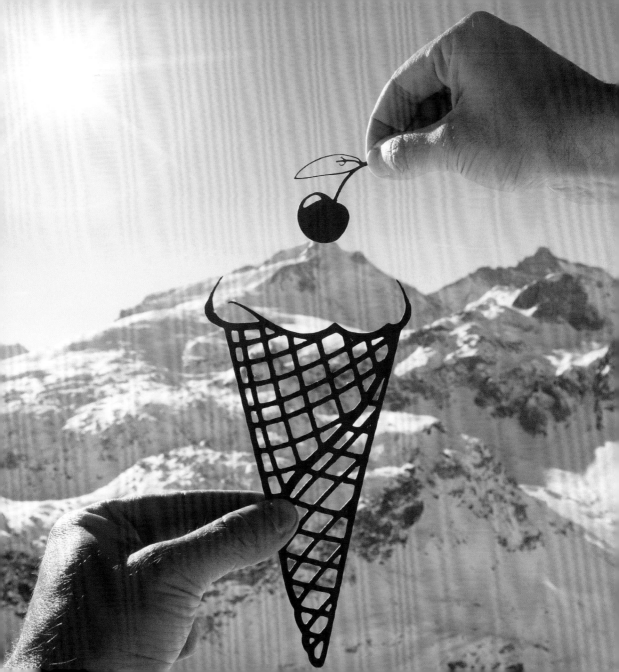

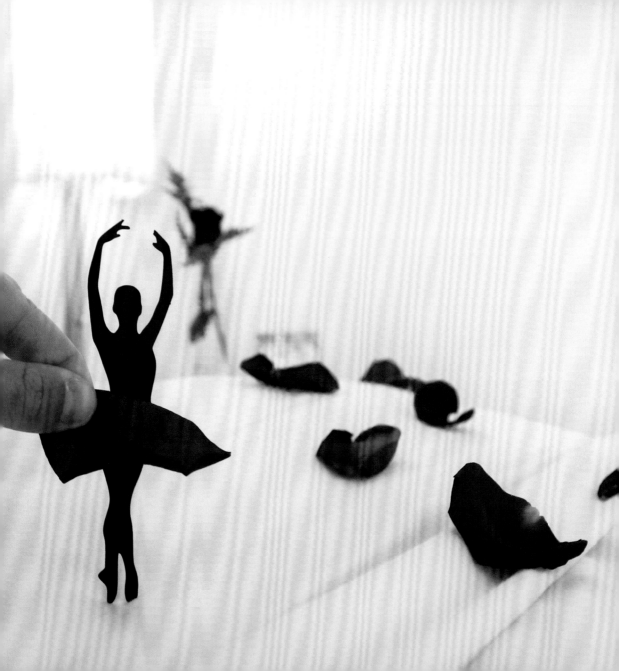

San Francisco, California, USA

W HOTEL

I was strolling back to my hotel on my own and walked past a florist's as it was about to shut. I noticed they had one rose and for whatever reason it inspired this idea. So I bought it and placed the petals on my hotel bed to set up the shot. I'm just glad housekeeping didn't knock on the door at that point – I might have had a lot of explaining to do.

Lisbon, Portugal

LISBON CATHEDRAL

Seeing recognisable objects and shapes in random or unrelated objects is called *pareidolia*. So the next time you see Jesus on your toast, or a face in the clouds – that's called *pareidolia*. Or it might be the second coming.

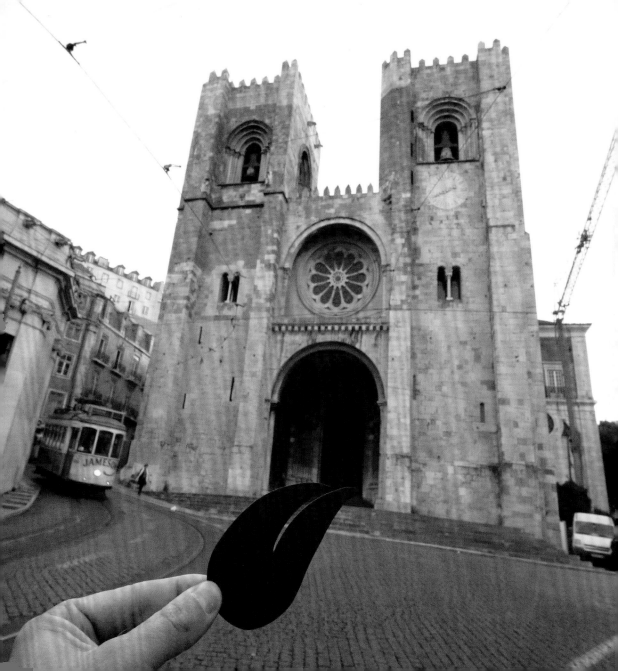

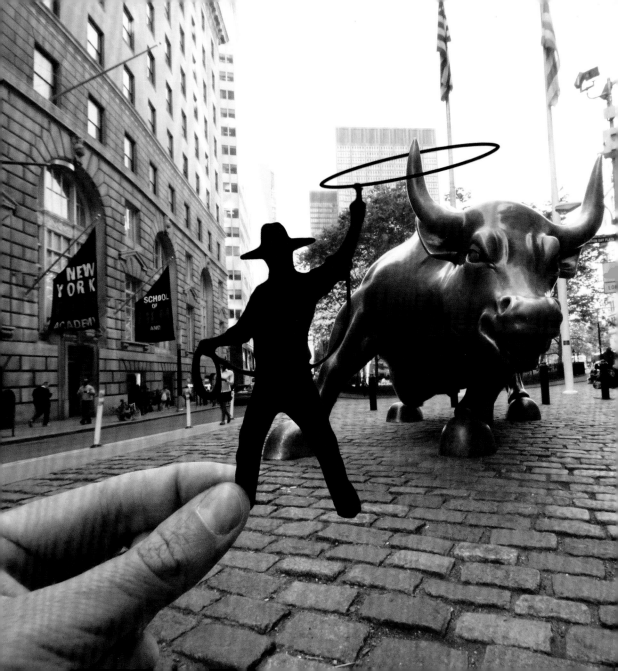

'CHARGING BULL'

by Arturo Di Modica

Let me take you back to a December night in 1989. It's late, Wall Street is empty except for a lonely night watchman. It takes him eight minutes to finish his rounds of the Stock Exchange. A man named Arturo Di Modica knows this because he's been casing the area every night for the last week. When the watchman is out of sight, Di Modica steers a truck down Wall Street and pulls up in front of the large Christmas tree. He and a group of friends jump out. In under five minutes they manage to lower a 3,200kg bronze sculpture from the back of the truck and leave it under the tree. When it's done, the men take off in the truck but Di Modica stays behind. He wants to see the watchman's reaction. In fact, until noon the next day he stays hidden around a corner watching New Yorkers fall in love with his Christmas gift to the city. *Charging Bull* has now moved here to Bowling Green, but if you ever visit the statue you'll see the same thing Di Modica saw that morning - people stopping to admire this fierce, bold, beautiful sculpture.

Auvergne-Rhône-Alpes, France

VAL D'ISÈRE

The popularity of skiing is somewhat down to Sir Arthur Conan Doyle. He moved to the Alps in 1893 (the mountain air was prescribed to aid his wife's health), and learnt to ski with the help of two local brothers. 'You let yourself go,' he once wrote, 'getting as near to flying as any earthbound man can.' Doyle predicted that in the future, hundreds of people would come to the Alps for 'ski season'. He wasn't wrong.

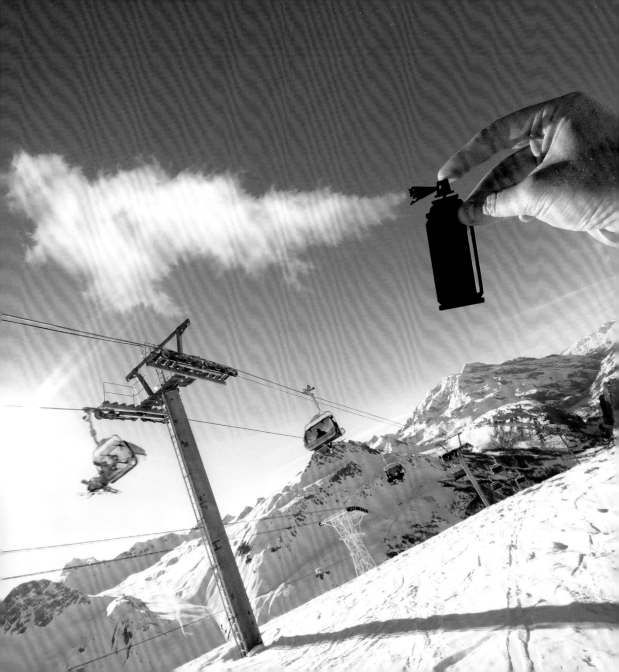

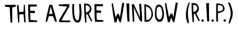

Gozo Island, Malta

THE AZURE WINDOW (R.I.P.)

This was the highlight of Gozo Island, a natural wonder formed by the erosion of a limestone cliff face. Unfortunately in 2017 the whole thing collapsed into the sea in a violent storm. I feel genuinely privileged to have had the chance to see it.

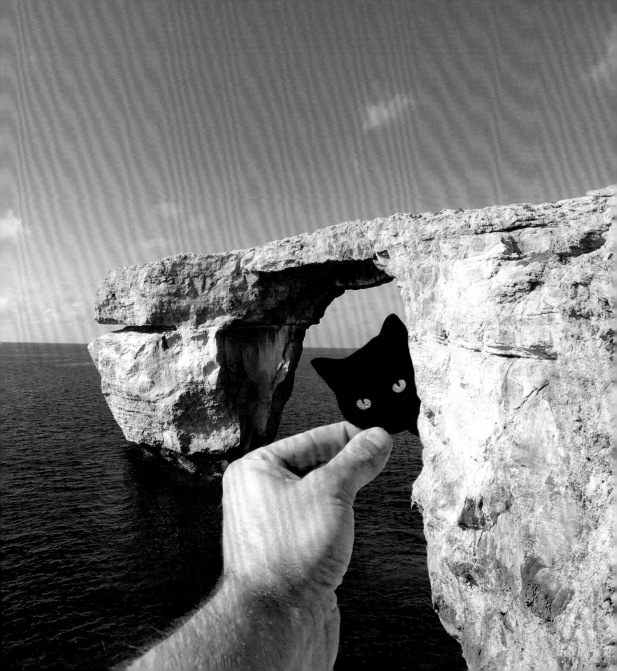

Edinburgh, Scotland, UK

ARTHUR'S SEAT

It's a local tradition that on May Day every year, young women from Edinburgh climb the hillside here and wash their faces in the morning dew. According to legend, the dew will keep them looking youthful and beautiful.

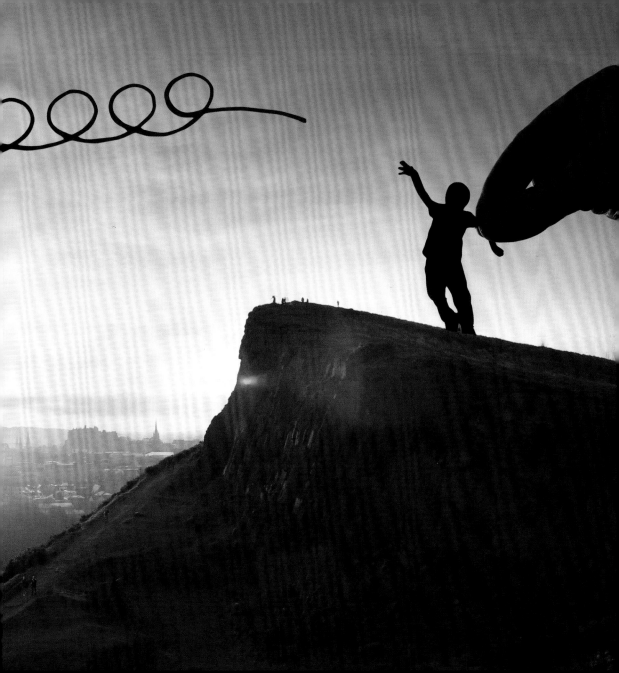

Rio de Janeiro, Brazil

RIO DAS PEDRAS

There was something quite dramatic and Tim Burton-esque about this tree. So I thought a lone, silhouetted figure swinging in the breeze felt like a suitable ode to the visionary director.

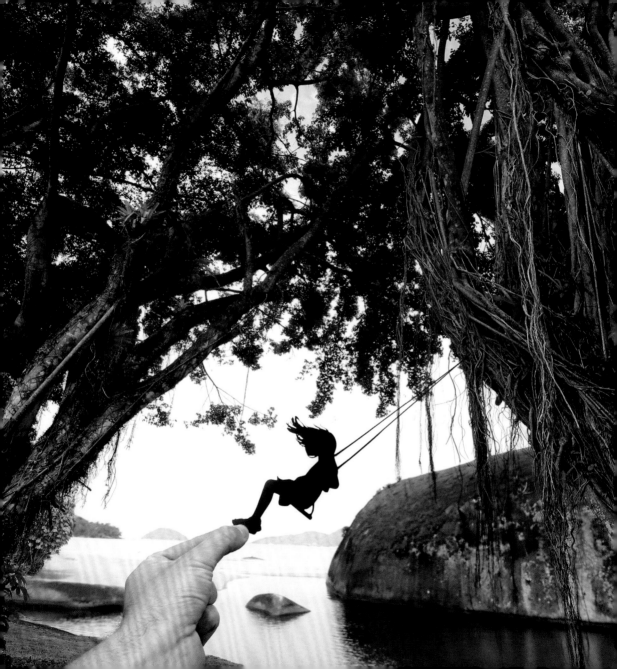

Auvergne-Rhône-Alpes, France

VAL D'ISÈRE

The shadows that the sun was casting were so long that the shadow of my hand sort of ruined the shot, so this is a rare image of a cut-out on its own.

BEHIND THE SCENES

I love travelling and I love bringing my style of photography to different scenes around the world, but I'd be lying if I said it was an easy task. I'm always trying to think of new ideas and that means doodling on flights, late nights at my desk making cut-outs, and endless hours of research into finding the best vantage points for scenery. I wouldn't change a thing, though; I love the whole process.

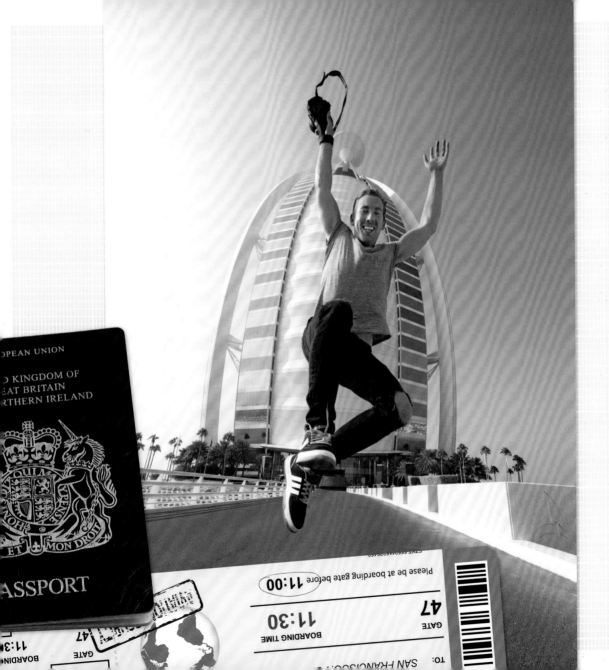

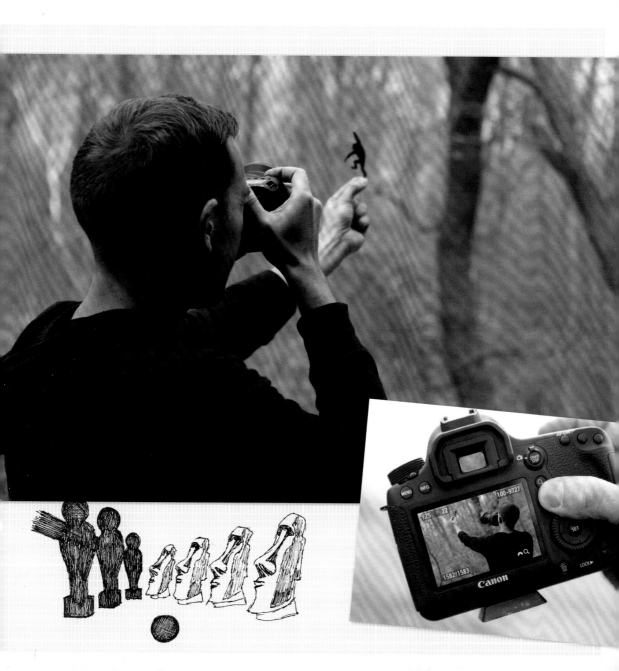

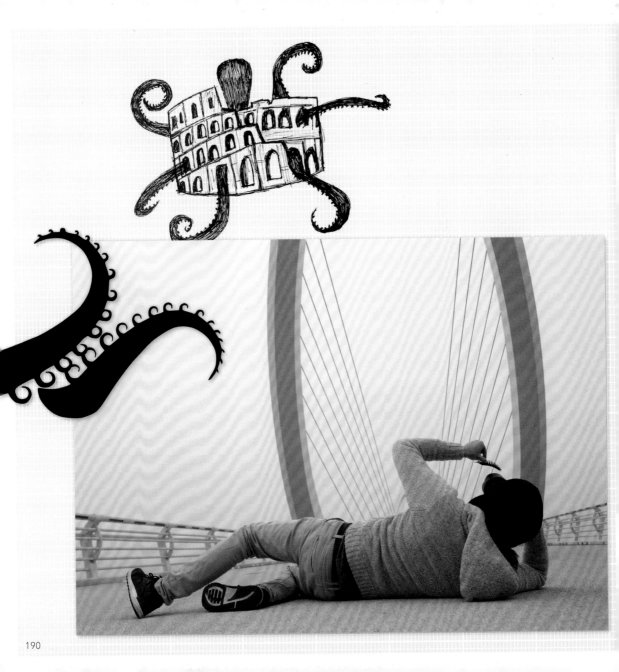

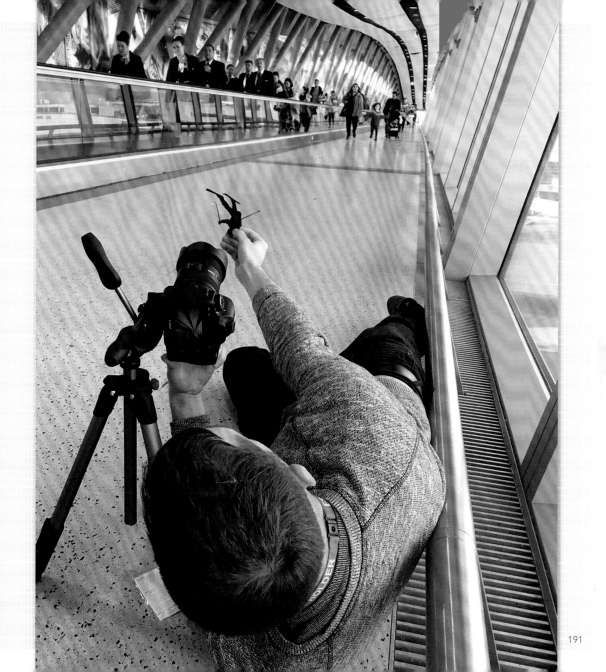

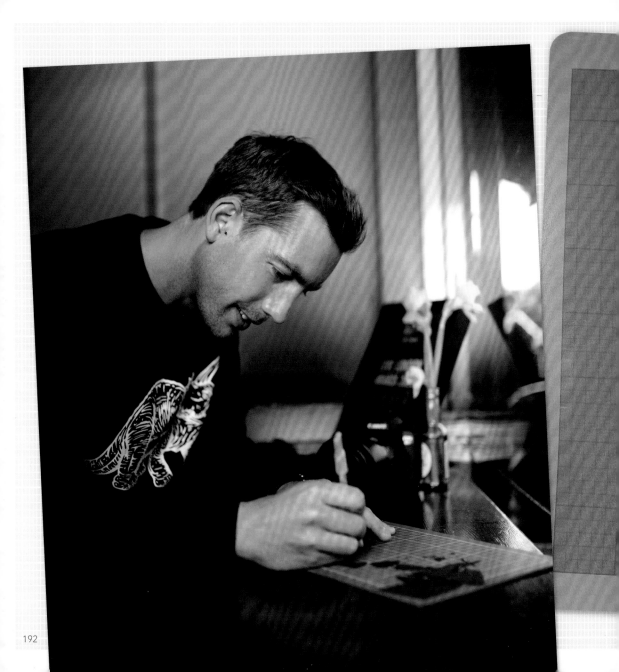

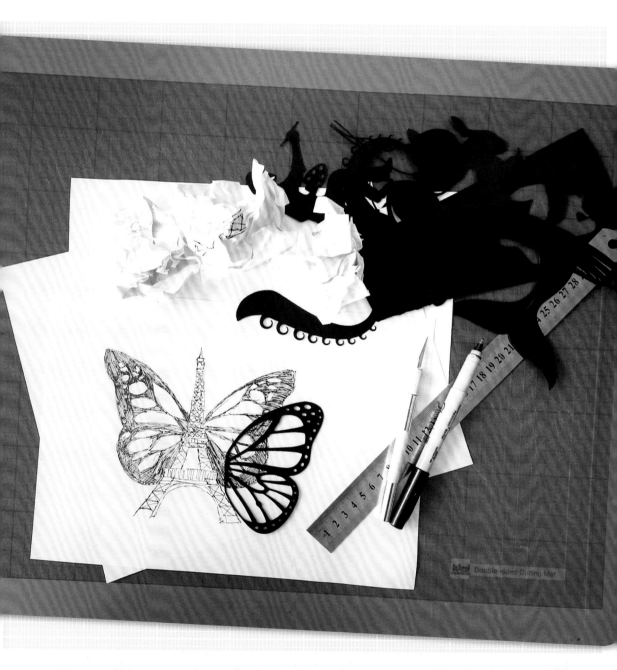

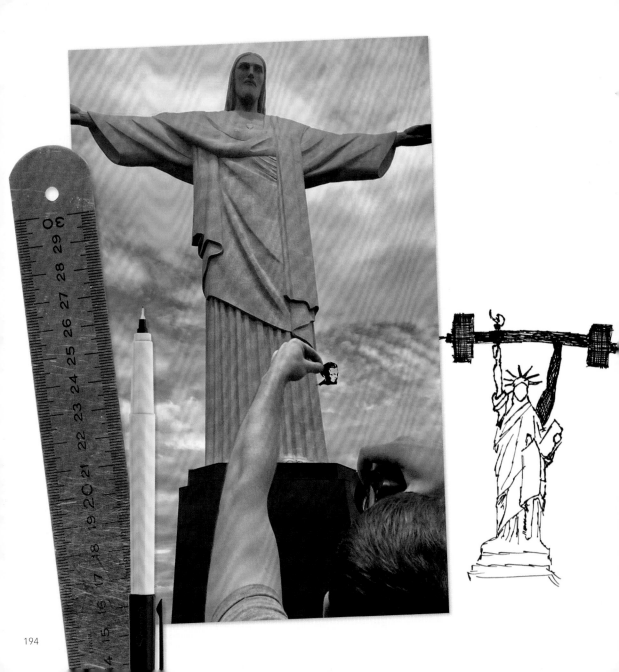

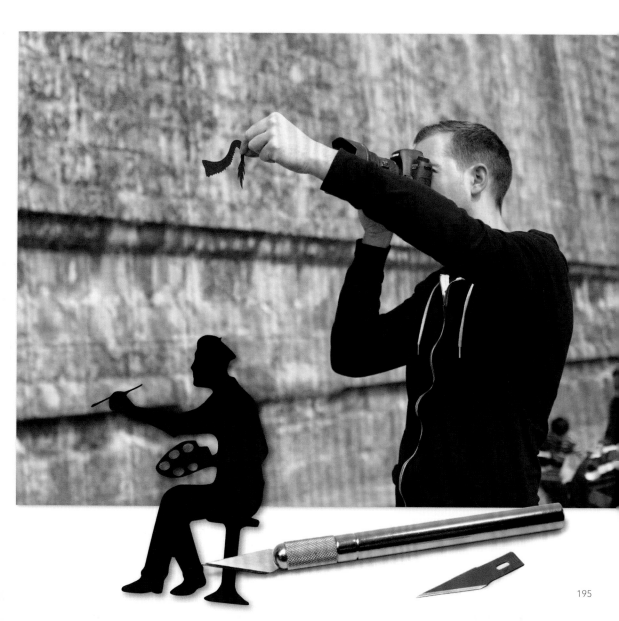

Despite having a cool idea, making carefully laid
plans and being fairly experienced at doing this now,
things don't always work out...

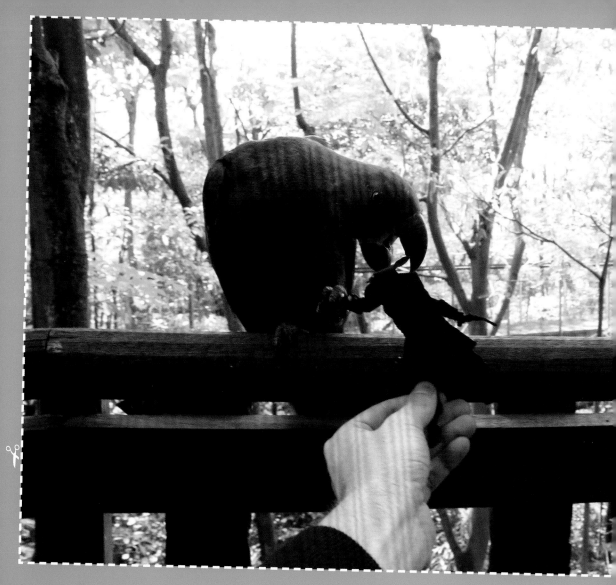

I thought the concept of a parrot sitting on the shoulder of
a pirate might be fun, but the parrot had other ideas.

The wind is my nemesis when it comes to delicate cut-outs.

Trying to get a half-submerged shot with a flimsy paper cut-out in the water proved to be a tricky process.

I should have made this cut-out bigger so that it would cover
the entirety of the top of the fountain to make the illusion work.

Usually I'd just hold the cut-out closer to the camera
but due to the focal length, the cut-out would be out
of focus. And I couldn't just move because there was a
couple ambitiously kissing just out of frame, and I didn't
really want that in my shot.

I tried so many attempts to get this right, but none of them quite worked.

I think it's one of my favourite concepts, but I didn't manage to capture it exactly how I wanted it.

D.I.Y.

Now it's your turn!